Digital
Photography
and Computing
for the Older
Generation

D1386204

Other Books of Interest

Acknowledgements

The author and publishers would like to thank the following for their help in the preparation of this book:

Olympus Optical Co (UK) Ltd.

Karl and Jamie at Highridge Computers of Burton-on-Trent for their excellent service providing new equipment, upgrades and repairs.

(Web site: www.highridge.net E-mail: info@highridge.net)

Digital Photography and Computing for the Older Generation

Jim Gatenby

BERNARD BABANI (publishing) LTD
The Grampians
Shepherds Bush Rd
London W6 7NF
England

www.babanibooks.com

Please Note

Although every care has been taken with the production of this book to ensure that any projects, designs, modifications and/or programs, etc., contained herewith, operate in a correct and safe manner and also that any components specified are normally available in Great Britain, the Publishers and Author do not accept responsibility in any way for the failure (including fault in design) of any project, design, modification or program to work correctly or to cause damage to any equipment that it may be connected to or used in conjunction with, or in respect of any other damage or injury that may be so caused, nor do the Publishers accept responsibility in any way for the failure to obtain specified components.

Notice is also given that if equipment that is still under warranty is modified in any way or used or connected with home-built equipment then that warranty may be void.

First published - October 2003
Reprinted - December 2003
Reprinted - April 2004
Reprinted - June 2004
Reprinted - October 2004
Reprinted - February 2005
Reprinted - May 2005

British Library Cataloguing in Publication Data:

A catalogue record for this book is available from the
British Library

ISBN 0 85934 602 1
Cover Design by Gregor Arthur
Printed and bound in Great Britain by Cox & Wyman Ltd

About this Book

This book attempts to show, in plain English, how a digital camera and a home computer can together provide a most enjoyable and rewarding new hobby. This latest branch of photography is simple to use, yet more powerful, versatile and convenient than the traditional 35mm film camera. A home computer introduces exciting new ways of enhancing, editing, viewing and sharing photographs with friends and family anywhere in the world.

The first chapter gives an overview of the entire digital process, followed by chapters describing the features of a digital camera and the transfer of images from a camera to a computer.

The book then describes the facilities, built in to modern computer systems, for managing and viewing photographs, such as film strips and slide shows. The next chapter explains how to *archive* your photographic collection onto a Compact Disc, ensuring its survival for future generations. (You can even add old photographic prints to your digital collection using an inexpensive *scanner*).

Later chapters describe popular software, such as Photoshop Album, which organizes your entire collection into easily recognizable categories. Enhancing photos by simple one-click methods is then covered followed by chapters describing the very popular Paint Shop Pro and Photoshop Elements digital editing programs.

The final chapter shows how you can produce high quality colour prints and share your photographs with friends and relatives around the world, by e-mailing copies or by posting onto a World Wide Web site. All of this work can be carried out easily from the comfort of your own home.

About the Author

Jim Gatenby trained as a Chartered Mechanical Engineer and initially worked at Rolls-Royce Ltd using computers in the analysis of jet engine performance. He obtained a Master of Philosophy degree in Mathematical Education by research at Loughborough University of Technology and taught mathematics and computing to 'A' Level for many years. His most recent posts included Head of Computer Studies and Information Technology Coordinator. During this time he has written many books in the fields of educational computing and Microsoft Windows.

The author has considerable experience of teaching students of all ages, in school and in adult education. For several years he successfully taught the well-established CLAIT course and also GCSE Computing and Information Technology. The author is himself a member of the over 50s club and an enthusiastic convert to digital photography.

Trademarks

Microsoft, MSN, Outlook Express, Hotmail, Windows, and Windows XP are either trademarks or registered trademarks of Microsoft Corporation. Norton AntiVirus is a trademark of Symantec Corporation. nero-BURNING ROM is a trademark of Ahead Software AG. Easy CD Creator is a trademark or registered trademark of Roxio Inc. Paint Shop Pro is a trademark or registered trademark of JASC Inc. Adobe Photoshop, Adobe Photoshop Elements and Adobe Photoshop Album are trademarks of Adobe Systems Incorporated. Epson is a registered trademark of Seiko Epson Corporation

All other brand and product names used in this book are recognized as trademarks or registered trademarks, of their respective companies.

Contents

4

5

6

7

8

9

10

11

Introducing Digital Photography

Introduction

In later life there should be more time to pursue hobbies and leisure activities, without the pressures of work or raising a family. Many older people make visits to places of interest and take frequent holidays, including foreign travel, perhaps to visit family and friends who have emigrated. Some older people support their children by caring for grandchildren, while others welcome the increased freedom to "potter about" at home and spend time in the garden.

All of these activities are enriched if they can be recorded with photographs; then you can relive these moments during the long winter months. Or you can share the pictures with others by sending them to friends and relatives.

The arrival of the digital camera, together with the home computer, greatly assists the creation of photographs. You now have complete control over the entire process of taking photographs, viewing in several different ways and printing in various formats, all from the comfort of your own home.

In addition you can store photographs more neatly, edit, modify and improve them and share them with friends and relatives using e-mail and the Internet.

Digital cameras are easy to use and the entire process of creating photographs with a computer is simple and enjoyable. There is none of the mystique or specialist skills associated with traditional photography and dark rooms. This chapter gives an overview of the process of creating digital photographs using a digital camera and a home computer.

Although digital cameras have been around for a number of years, they were initially very expensive and beyond the reach of many people. Nowadays some digital cameras can be bought for less than £50. Mid-range cameras like the Olympus C-220 ZOOM model shown below cost around £200 and more expensive models are also available.

Outwardly the digital camera is similar in appearance to the traditional 35mm camera, though often much smaller and more compact.

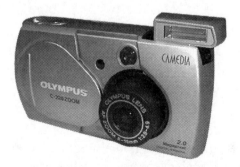

The zoom lens is controlled by a button on the top left. The flash unit protrudes on the top right. On the back is the viewfinder and a small monitor for previewing photos.

When you take photographs with a digital camera, the images are stored on a small removable *memory card*, as shown below. This replaces the 35mm film used in the conventional camera. With the digital camera there's no longer a film to "wind on" after every shot.

Memory cards of various sizes are available, some of them capable of holding over a hundred photographs or *digital images*, as they are known. In the digital camera, the image is made up of millions of picture elements or *pixels*, and these are stored in the form of *binary* 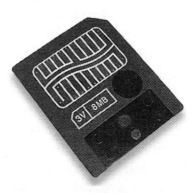 digits. Binary digits consist of patterns of 0s and 1s and so images represented in this way are known as *digital photographs*.

A small screen about 1.5 inches wide on the back of the digital camera allows you to preview the photograph as soon as it's been taken. If you are not satisfied with the image, it can be deleted straightaway. This is done using small menus operated by buttons on the back of the digital camera, described in more detail later in the next chapter.

One of the main advantages of digital photographs is convenience. Instead of removing a film and sending or taking it to be developed, you simply connect the digital camera to your computer, using a cable provided with the camera. The photographs are then copied to your hard disc. Alternatively, the images can be copied using a separate *memory card reader*. These are inexpensive devices which connect to your computer with a cable.

The memory card is removed from the camera and inserted into the card reader to allow the copying of photos to begin.

After copying, you can view the photos immediately on your computer screen, instead of waiting days for them to be developed. The following screenshot shows a screen display in Microsoft Windows Explorer. A choice of screen layouts is available to view your photographs, including the **Filmstrip** arrangement shown below.

The complete collection of photographs in the folder is displayed as the strip of "thumbnail" or miniature images along the bottom of the screen as shown below. The enlarged image shown is obtained by clicking on the appropriate thumbnail below. Or you can click on the forward and back buttons shown on the left, to scroll through the photographs, displaying each photograph in turn, in enlarged view.

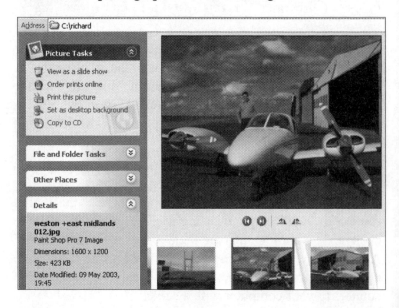

The **View as a slide show** option shown on the previous menu under **Picture Tasks** displays each photograph in turn in an automatic sequence, filling the whole screen.

You can also view the photographs as a "slide show" on an ordinary television. This is done by connecting the digital camera to the video socket on the television, using a special video lead normally provided with the camera.

Printing Digital Photographs

With the traditional 35mm camera you may find that some of your photographs are of poor quality, although you must still pay the cost of developing good and bad prints alike. With a digital camera, however, you can select which images to print and reject any you don't want to print. Then the selected images can be printed in colour using one of the many affordable computer printers now available. The **Photo Printing Wizard** in Windows XP helps you to print your photographs in various formats, sizes and quality, as shown on the next page. If you are using special photo quality "glossy" printer paper, which is quite expensive, several images can be printed on one sheet of A4 paper.

Using special photographic paper, colour prints of very good quality can be produced with the sort of inkjet printer fitted to most home computers. Unless you are a professional photographer or very discerning enthusiast you are unlikely to notice the difference between digital photographs and those produced using a conventional camera.

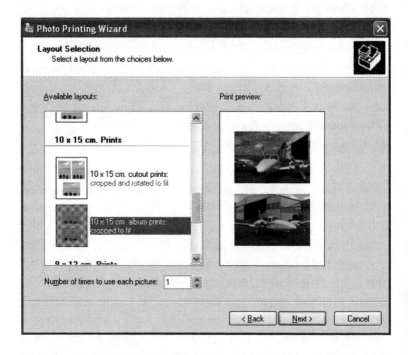

If you want professionally produced glossy prints, your digital images can be e-mailed to a photographic company such as Jessops, who will send the glossy prints to your home by the conventional letter post.

Scanning Photographic Prints

Prints made in the traditional way using a 35mm film camera can be converted to digital photographs and imported into a computer using a *scanner*. The images can then be saved on your hard disc and viewed, edited, organized or e-mailed in exactly the same way as images created using a digital camera.

The scanner might be used, for example, if you wanted to e-mail copies of photographs created by someone who doesn't have a digital camera. Alternatively, you might have lots of old photos stored in boxes in the attic. These could be scanned into the computer and edited, enhanced, e-mailed, archived onto CDs and managed in many different ways, as described later.

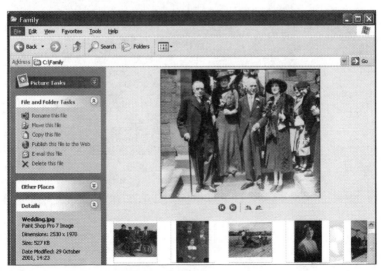

Editing Digital Photographs

Various *digital editing* programs such as Adobe Photoshop Elements and Paint Shop Pro allow you to make improvements to the appearance of your photographs. These include the removal of the "red eye" effect often seen in portrait photographs, also adjustments to brightness and contrast and the removal of defects such as scratches and unwanted objects. It is also possible to "crop", i.e. trim, a picture to remove any unwanted areas. Alternatively a photograph can be enlarged or scaled down using the image editing software.

The screen shot below shows the popular digital editing program Paint Shop Pro, from Jasc Software.

Using Digital Photographs

Apart from viewing on a computer or TV or as prints on glossy paper, digital photographs can be inserted directly into a document in a word processor or desktop publishing program, in order to enhance and illustrate the text. Or they can be posted to a Web site for viewing by a wider audience. Digital photographs can be sent between friends and family around the world as *attachments* to e-mail messages. A digital photograph can also be included within the body of the *text* of a message, as shown below in an example from the Microsoft e-mail program Outlook Express.

Archiving Your Photographs

Initially digital photographs will be saved on your hard disc. Here they can be organized into categories in folders with meaningful names. A digital photograph is saved on your hard disc like any other sort of file, such as a word processing document. All of the normal file handing operations can be applied to the digital photograph, such as copying, moving, renaming and deleting.

Eventually you may wish to make a more secure archive of your digital images, especially for those photographs you want to keep for the long term. Files on your hard disc, including photographs, although relatively secure in the short term, can sometimes be lost if you are unlucky. For example, the hard disc may need to be completely "wiped" to solve a technical problem. Or your photographs could be accidentally deleted by giving an incorrect command.

So to be really safe you need a backup copy of all of your photographs. A good medium to make a permanent archive for your photographs is the *Compact Disc* or *CD-R*. These are very cheap, (as little as 20p or less) and are also extremely reliable, if not indestructible. One CD-R can hold several hundred digital photographs and is therefore ideal for archiving your entire collection of digital photographs in a neat, reliable and efficient manner. You will probably change computers several times over the years and it will be easier and safer if your digital photograph collection is backed up onto one or more CDs.

That completes this introduction to digital photography. All of the points outlined in this chapter are discussed in more detail in the remainder of this book.

The Digital Camera

Introduction

The digital camera is obviously the centre-piece of the digital photography process, but as will be seen in later chapters, there is far more to the subject than just taking photographs. For example, you can create digital photographs by using a scanner to digitize prints made with a conventional 35mm film camera. In the past, photography has often seemed a complex subject. Apart from holiday "snappers" using simple, instant cameras, there are enthusiastic amateurs with more expensive cameras and perhaps their own dark room, through to the professionals with thousands of pounds worth of equipment.

The arrival of digital cameras and computers has made it possible for the ordinary person to produce excellent results, with the minimum of effort and without specialist training. This is not to suggest that a digital camera and a personal computer alone will enable you to start a new career as a professional photographer.

It does mean however, that you will be able to produce pleasing photographs more conveniently and with more viewing and printing options. You can have total control over the whole process, without leaving home and without having to master complex and sometimes messy techniques for developing and printing photographs.

Choosing a Digital Camera

In choosing a digital camera, the range is enormous and depends on your budget and the quality of photographs required. In this context, picture quality refers to the amount of fine detail or *resolution* in a photograph. This topic is discussed shortly, but is a major factor in determining the cost of a camera. At the cheapest level, you can buy a digital camera for under £50. In this price range, the quality of the pictures will be quite basic and such a camera might typically be used to record parties or light-hearted events where quality is not too critical. Such images would be suitable for e-mailing or posting to an Internet Web site, rather than for high quality prints.

Prices of digital cameras are falling continuously, but at the time of writing, if you spend, say, £150-£300 this will enable you to buy a mid-range digital camera capable of producing good quality pictures. Shown below is a diagram of the Olympus C220 Zoom, costing about £200.

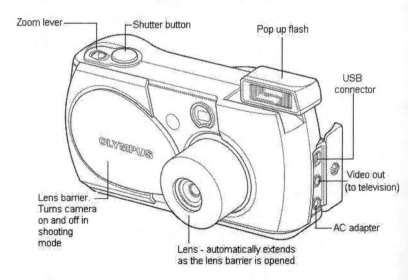

Photographs produced using mid-range cameras should be comparable, (at least to the eye of the average user), with those produced using the traditional 35mm film camera.

For the enthusiastic amateur photographer there are many excellent digital cameras in the £300-£500 price range, while some models for professionals may cost more than £1000. Although some professionals still prefer the traditional 35mm film camera, others are turning to the digital versions for at least part of their work. Without a digital camera, any photographs intended for publication in magazines or on the Web must first be input into a computer using a *scanner* to *digitize* photographic prints. Scanning prints is discussed later in this book. The digital camera eliminates this operation by providing images, stored in its memory, ready to be transferred via a computer, to the Web or to a publishing program.

In order to choose a digital camera it will probably help if you understand some of the technical terms involved. Fortunately there's not a great deal of jargon to learn in digital photography. In any case, many of the settings and controls on a digital camera are automatic and you can get by with simply "pointing and clicking" as you do with a cheap automatic film camera. If you do want to alter the settings, many digital cameras have a small LCD or TFT screen or monitor on the back. Settings can be displayed and altered through a system of menus navigated by four arrow buttons on the back of the camera, as shown on the next page.

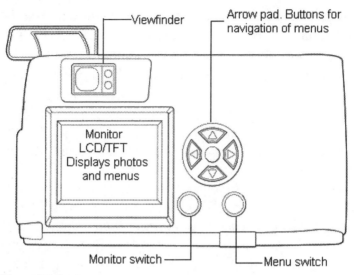

Viewfinder

Arrow pad. Buttons for navigation of menus

Monitor
LCD/TFT
Displays photos
and menus

Monitor switch

Menu switch

Resolution

This is one of the main selling points on digital cameras and refers to the number of *small pixels* or *picture elements* (small coloured squares) used to make up a photograph. Higher resolutions mean the images will be of better quality i.e. greater definition and showing more detail. This means they can be enlarged and still retain the clarity of the image. Higher resolution images take up more storage space than low resolution versions. You can enlarge photographs using a variety of software tools; low resolution images become "chunky" when enlarged.

The resolution is determined by a device known as the *CCD (charge coupled device)* in the camera. This, together with the memory, replaces the film in the conventional camera. The CCD is an *image sensor* which converts light from the image into the electronic pulses stored in the *memory* of the *digital* camera as *binary digits* (0's and 1's). (Memory is discussed shortly).

Cheap cameras costing under £100 may have a resolution of, say, 640x480 pixels, giving a total resolution of 300,000 pixels. Such cameras are suitable for posting pictures on the Web or e-mailing to friends. These low resolution pictures can be transferred quickly and take up very little storage space.

My mid-range camera enables the resolution to be set at several different levels. The highest quality resolution is 1600x1200 pixels, or about 2 million pixels. The resolution of such a camera is usually described in advertising literature as 2 *megapixels*.

Digital images captured and stored at a high resolution take up a lot of space in your memory card or on your hard disc. Setting a camera to a low resolution enables far more photographs to be stored on a given memory card.

In general, a 2 or 3 megapixel camera should be able to produce good quality postcard size prints. For large, high quality prints (A4 and above, say) or for professional work, cameras with resolutions of 5 or 6 or more megapixels are available.

Digital and Optical Zoom

Sometimes you may want to take a close-up shot of an object, but for some reason you can't get physically close; for example, when trying to photograph wildlife in your garden. The zoom feature on a digital camera allows you to make close-up shots without moving nearer. Alternatively you can "zoom" out to make a wide-angle view.

Many digital cameras are quoted as having both *optical* and *digital zoom*. *Optical zoom* involves the lens being physically moved in and out by an electric motor.

Optical zoom alters the *focal length* of the camera, the distance between the lens and the image sensor. This is controlled by the zoom lever with positions marked "W" (for wide angle or zoom out) and "T" (for telephoto or zoom in.) The zoom lever is shown on page 12.

The *digital zoom* feature cuts out (or "crops") an area in the centre of the image and magnifies it. Optical and digital zoom can be used separately or in combination. Some cheaper digital cameras have no zoom at all.

Optical zoom is considered the most useful, since the cropping and enlargement performed by digital zoom could equally be carried out later using *digital editing software*. (Digital editing software is discussed later in this book).

Optical zoom magnifications of 3x and 4x are adequate for the general user, although some cameras are available with stated magnifications of 8x or even 12x. Digital zoom magnifications are usually in the range 2x to 5x.

The Memory of a Digital Camera

Digital cameras use a memory device or disc instead of a roll of film. Two of the most common are the SmartMedia card and the CompactFlash card. Memory cards like this are called *solid state* devices, as they have no moving parts, unlike other data storage devices such as hard and floppy discs.

A camera may initially be supplied with an 8MB card but larger capacity cards up to about 128MB can be bought later.

You simply pull out the old card and slide in the replacement.

After you have taken some photographs, the images remain on the card until you delete them, using the menus on the screen on the back of the camera, operated by the 4 arrow buttons shown on page 14.

The lines on the SmartMedia card shown on the previous page are contacts which connect to the electronic circuitry of the camera. The circle on the right shows where you can place a special "write protect" sticker. This prevents accidental deletion of images from the card. The rectangular area at the bottom of the card is used to attach a label to identify the particular card. This is useful if you have several memory cards for your camera. For example, some cameras are initially supplied with an 8MB card, but this can be replaced by a bigger card such as 16MB, 64MB up to the SmartMedia maximum of 128MB. When going on a long trip or holiday, it's worth taking all of your cards with you in case you run out of storage space.

The photographs taken with a high resolution setting i.e. high quality, take up a lot of memory. Therefore the number of images you can store on a card depends on the resolution you have set on your camera. As a guide here are a few approximate figures for the SmartMedia card:

SmartMedia Capacity	Number of Still Pictures per Card	
	High Resolution	Low Resolution
8MB	5	49
32MB	22	199
64MB	45	398
128MB	91	798

Other types of storage used in digital cameras include the Memory Stick from Sony and the Microdrive from IBM. The Microdrive is a miniature hard disc which fits into the same slot as the Compact Flash card. The advantage of the Microdrive is that it provides a 1GB (gigabyte) storage capacity, allowing hundreds of images to be stored. At the time of writing, one of the latest developments is the xD Picture Card, a type of memory with a potential capacity of several gigabytes (GB).

Some digital cameras use an ordinary floppy disc to store photographs. While these are cheap and readily available, their capacity of only 1.44MB means they are only suitable for storing low resolution images. However, this may be adequate if you are only saving a few images for e-mailing or posting to a Web page. In these situations low resolution pictures are the norm since they can be copied quickly and they don't take up much storage space (on disc, etc.)

The JPEG File Format

It should be pointed out that the previous notes assume that images are stored in the JPEG (Joint Photographic Experts Group) format. This is a popular way of storing photographs used by most digital cameras. The JPEG file format uses a method of *compression* to enable pictures to be stored economically or sent as e-mail attachments in a reasonable time. Stored photographs often contain a lot of data which can be removed without any obvious loss in picture quality. This may be because the same data is repeated unnecessarily or because it represents details not visible with the human eye. The compression process removes this superfluous data from photographic images.

The TIFF File Format

Some digital cameras allow photographs to be stored in the TIFF format (Tagged Image File Format) in addition to the JPEG format. This format is used for storing very high quality pictures. TIFF images take up a lot of storage space, so you might, for example, only be able to store *one image* on a 16MB memory card.

Printing from a Memory Card

If you don't have a computer system and printer for printing your digital photographs, you can simply remove the memory card and take it to various High Street stores who provide a high quality printing service. The card is read using a special *memory card reader* (discussed later).

Deleting Images from the Memory Card

If your camera is equipped with a small preview screen on the back, you can have a look at your photographs before printing or e-mailing, etc. Any images you don't want can be deleted from the memory, thus increasing storage space for new images and saving the expense of unwanted prints.

Batteries

Batteries are a major issue with digital cameras, especially for long trips or holidays away from base. Power is used by the digital camera to illuminate the TFT monitor, to power the zoom of the lens and to download photos to a computer.

Often the camera is supplied new with two standard AA alkaline batteries obtainable anywhere, but these are very quickly exhausted.

Rechargeable Batteries

One solution is to buy some *rechargeable* AA batteries such as NiCad or NiMH. I have found NiMH batteries to be quite satisfactory. It's worth having a spare set and a battery charger, costing a few pounds, as shown below.

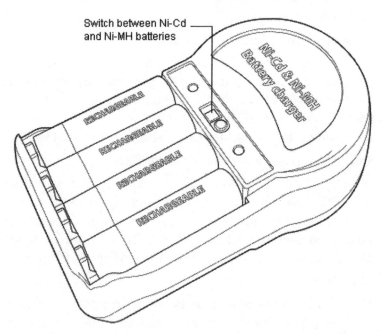

Switch between Ni-Cd and Ni-MH batteries

Of course, if you run out of battery power on holiday, standard AA batteries will suffice for a short time. Rechargeable *lithium ion* batteries are becoming popular in more expensive cameras because of their long life.

Apart from batteries, some digital cameras, such as the Olympus range, also have an optional *mains adapter*. This is useful when "downloading" images from your camera to a computer, a process very heavy on battery power.

Flash

Most digital cameras, apart from some of the budget models costing under £100, have a built-in flash feature. On the Olympus this pops up automatically when you slide back the lens barrier. There are several flash settings including auto-flash when the flash fires spontaneously in low light conditions.

Another mode causes the flash to fire every time the shutter button is released and yet another flash mode reduces the red-eye phenomenon which sometimes occurs in portrait images. It is also possible to switch off the flash altogether.

Some photographers may prefer to use a more powerful separate flash gun, rather than the flash facility built into the camera. In this case a more expensive digital camera, with a special socket or "hot shoe" to allow the fitting of a flash gun, may be needed.

Using a Digital Camera

The following notes are based on an Olympus digital camera, but are also relevant to digital cameras in general.

The camera is switched on by sliding away the lens barrier on the front of the camera. The lens extends automatically and the flash unit pops up on the top right. At the back of the camera on the top left is the viewfinder with red and orange indicator lights.

Viewfinder

Indicator lights

Also on the back of the camera is a small TFT (Thin-Film Transistor) or LCD screen or monitor, usually about 1.5 to 2 inches wide as shown on page 14. A small button next to the screen acts as an on/off switch. The monitor can be used as an alternative to the viewfinder. It is also used to review photographs you have already taken and stored in the memory. These can be examined and any you don't want can be deleted immediately. Digital cameras without a monitor (also known as a TFT screen) are at a major disadvantage in this respect. Without such a screen all photographs must be viewed on your computer's monitor or on a TV screen or printed on paper first, before you can decide which images to reject.

The monitor on the camera also displays several indicators informing you, for example, of the state of your batteries and the number of photographs which can be stored in the remaining space in the memory. The current setting for the resolution of the photograph is also displayed in pixels, for example 1600x1200.

Operations such as deleting unwanted photographs are carried out using a system of small menus which are displayed on the monitor. These menus are launched by pressing a small menu button on the back of the camera. To navigate the menus a cluster of four arrow buttons is also provided on the back of the camera, as shown on page 14.

Although you can usually obtain good results with the default settings which are preset on a new camera, many of these settings can be over-ridden using the menu system. These include settings to alter the resolution of the camera in megapixels, as discussed earlier. It is also possible to set the camera to record short *videos* or to put the camera in *macro mode* in order to take close-up photographs (under about two feet away from the subject, for example).

Taking a Photograph

When you take a photograph, first obtain the required shot using either the viewfinder or the monitor, together with the zoom facility.

The zoom is controlled by a small button on the top side of the camera on the right. When you are satisfied with the view, depress the shutter button *half way*. The camera *automatically focuses* on the subject and adjusts the *aperture* and *shutter speed* to give the optimum amount of light *exposure*. Keep the shutter button in the half way position until the green light appears on the side of the viewfinder. This means the focus and exposure are set. Now fully depress the shutter button to take the photograph and store the image in the camera's memory.

Most digital cameras automatically control the size of the aperture and shutter speed to optimize exposure, i.e. the amount of light reaching the CCD sensor. However, enthusiastic amateurs and professional photographers who like to have complete control over the camera may prefer a more expensive digital camera having manual settings which can override the automatic controls.

Once you have taken your photographs, you can review them on the monitor on the back of the camera and delete any you don't want. Otherwise the photographs will remain stored on your camera's memory (SmartMedia card, etc.), until you physically delete them using the menu system and buttons on the back of the camera. Individual photographs can be deleted or the entire memory can be "wiped".

Once back at home or your hotel room or holiday accommodation, you can:

- View the pictures on a television screen (using a special video cable provided with the camera).
- Download them to your computer.
- Save the pictures on your hard disc.
- View them on the computer monitor.
- Enhance and edit the pictures using digital editing software, often provided with the camera.
- Print the pictures on glossy photographic paper.
- E-mail them to a friend or relative.
- Post the pictures onto a Web site for others to view.
- Archive the pictures permanently by saving them on a Compact Disc (CD-R or CD-RW).

The above topics are covered in more detail in the remaining chapters of this book.

Downloading Images to a Computer

Introduction

The previous chapter discussed, amongst other things, the taking of photographs and the storing of images in the memory of the camera - usually on a removable card or disc storage device. You can have an initial look at the results of your efforts using the small preview screen on the back of the camera shown on page 14. This will allow you to reject any unsatisfactory photographs and delete them using the buttons and menus on the back of the camera.

Viewing Your Photographs on a Television

If you want a full size view of your photographs straightaway, you can connect the camera to the video input socket of an ordinary television set. Then you can scroll through and view all of the photographs (which fill the whole TV screen) using the control buttons on the back of the camera. This option is very useful for viewing your photographs full size when you don't have access to a computer - for example when you're away on holiday or visiting friends or relatives who don't have a computer.

Some televisions are not fitted with the small, round, video input socket necessary to accept the camera's video cable. In this case, an adapter can be bought for a few pounds to connect the camera's video cable to the *Scart* connector, a large socket on the back of the television.

Reasons for Downloading Images to a Computer

If you want to take full advantage of your digital camera, you must *download* (i.e. transfer) your photographic images to your computer. Then they can be permanently saved on your computer's hard disc.

This will allow the original images to be deleted from the memory card or disc in the camera, enabling more photographs to be taken. If funds allow you might have a collection of cards, reducing the need to delete images.

Once stored inside your computer, a wide range of activities are possible with your photographs, including:

- Viewing in different arrangements, such as a slide show, filmstrip and as "thumbnails".
- Organising photographs into "albums" in various categories, with meaningful names.
- Enhancing and altering the images, using *digital editing* software. (Usually provided with the camera but several well-known packages can also be bought separately).
- Sending photographs to friends and relatives using e-mail.
- Printing on special glossy photographic paper.
- Posting photographs on Web sites.

All of the above activities are discussed in detail later in this book.

Methods of Downloading Images

Downloading images to your computer can be achieved in various ways:

Method 1

Connect the camera to a computer using a cable (commonly via the USB ports, discussed shortly). This method of connection is sometimes known as "tethering". Shown below is an Olympus camera together with the cable to connect the camera to one of the USB ports on a computer.

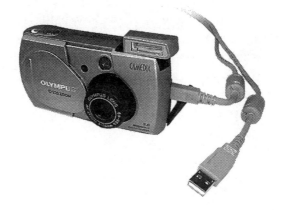

Method 2

Remove the memory card from the camera and insert it into a special *memory card reader* attached to the computer (discussed shortly).

Method 3

Insert the memory card directly into a special slot, available on some computers, particularly laptops.

Some photoprinters can print directly from a digital camera or from a memory card, without involving a computer.

Downloading Images Using a USB Cable

When you buy a digital camera, the package should include a CD containing software to transfer images from the camera to your computer. Installing the software should be simply a matter of inserting the CD and following the instructions on the screen. Windows XP, the latest version of the Microsoft operating system, is itself designed to enable the downloading of photographs from most makes of digital camera.

Using a cable connection for downloading photographs, while very convenient, places heavy demands on the camera's battery power. Very low batteries could cause problems during the downloading of photographs. Some cameras have an optional *mains adapter* which can be used to solve this potential problem. An alternative method is to buy one of the cheap memory card readers described later in this chapter. This takes its power from the computer.

USB Ports

USB ports are increasingly being used to connect peripheral devices to computers, including printers, scanners and digital cameras.

In the picture below the USB ports are the two small rectangular slots, usually located on the back of the computer.

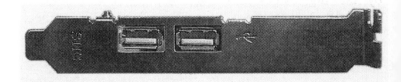

USB ports are popular because they enable very fast transfer of data and also because they allow "hot swapping", a process in which you can connect a USB device while the computer is up and running. If your computer doesn't have any USB ports or they have all been used by existing equipment, it's a simple matter to have some more fitted at a local computer repair shop.

It's also possible to buy (for a few pounds) an *adapter* or *hub* which enables 2, 4 or more USB devices to plug into one USB socket on the computer.

The next section shows how Windows XP software can be used to manage the downloading of photographs from a digital camera to the computer, where, amongst other things, they can be viewed and saved on the computer's hard disc. This is followed by a description of the downloading process using the CAMEDIA software provided with Olympus cameras.

Many *digital editing* programs, such as Adobe Photoshop Elements and Paint Shop Pro, discussed later, also allow the downloading of photographs from cameras and scanners, in addition to their primary role of enhancing and editing the photograph. This is usually achieved after selecting **File** and **Import** from the program's menu bar. You may need to obtain some special support software, known as *drivers*, to enable your camera to be recognised by the digital editing software. Drivers can often be obtained by a free download from the software manufacturer's Web site.

Using the Microsoft Scanner and Camera Wizard

With the computer up and running, the camera is connected to the computer using the USB cable provided, as previously described. Within a few seconds the following dialogue box pops up on your screen.

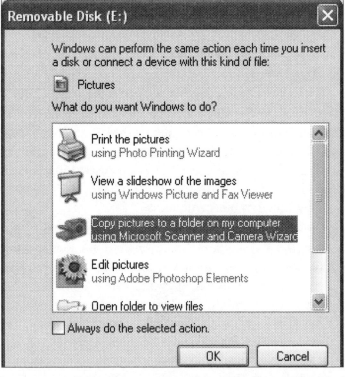

As shown in the above screenshot, Windows XP provides lots of options after downloading the photographs, including printing, viewing as a slide show on the computer, copying to a folder and editing using Adobe Photoshop Elements. The latter is a program which has been installed separately on this particular computer - other computers might display the name of a different package.

For the time being we will concentrate on the option shown highlighted in the previous screenshot, i.e. **Copy pictures to a folder on my computer using Microsoft Scanner and Camera Wizard**. (The scanner, described later, is included in the wizard because it is an alternative to the digital camera as a method of importing photographs into a computer. A scanner is used to convert traditional photographic prints into digital images stored on the computer's hard disc).

The other options listed in the previous screenshot, i.e. printing, viewing a slideshow using the Windows Picture and Fax Viewer and editing using Adobe Photoshop Elements are all covered in detail in later chapters.

With the **Copy pictures ...** option selected, click **OK** and the **Scanner and Camera Wizard** starts up. All of the images stored in your camera's memory are displayed as "thumbnails" in a grid, as shown below.

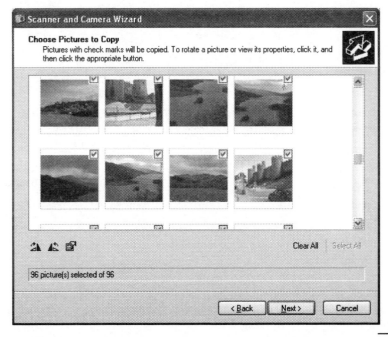

3 Downloading Images to a Computer

You can choose which images are to be copied to your hard disc by leaving or removing the tick in the top right hand corner of the thumbnail, as shown on the previous page. Apart from being able to tick individual images, there are buttons giving options to **Clear All** and **Select All**.

Clicking **Next** causes the following dialogue box to be displayed. Here you can give a group name to the batch of pictures being copied. You can also choose a location, i.e. a folder on your hard disc where the pictures are to be stored.

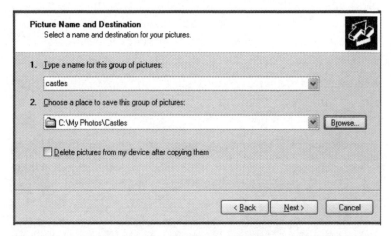

You may wish to place all of your photos within the folder **My Pictures**, which is provided by Windows within the **My Documents** folder. You can also create subfolders within **My Pictures**. If you choose to **Browse...** for a suitable folder, there is also an option to create a new folder with an appropriate name for the particular batch of photographs. Select the folder in which you wish to create the new folder, as shown on the next page.

In the example below I have selected the folder **My Photos**.
Click the **Make New Folder** button shown below. A small
box appears containing the words **New Folder**.

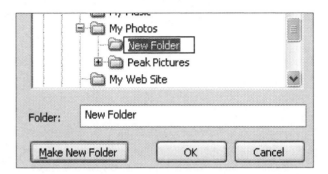

Replace these two words with the name you have chosen
for your new folder; in this example I entered the word
Castles. Much longer names can be used if you wish.

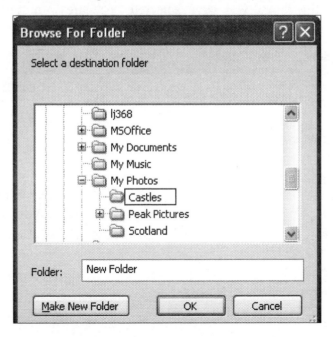

Click **OK** and you return to the **Picture Name and Destination** dialogue box, with your new folder displayed as shown below.

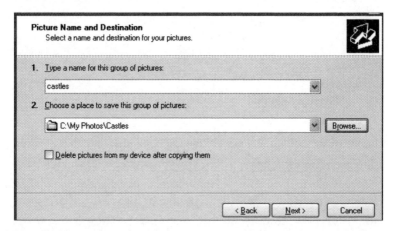

On clicking **Next** the pictures are copied to your hard disc into the folder you have selected. You are informed of progress as the pictures are copied.

After clicking **Next** you are given further options such as to publish the pictures on a Web site or order prints from an on-line printing service.

These topics are discussed later, so for now we select the bottom option **Nothing. I'm finished working with these pictures** and click **Next**.

The **Scanner and Camera Wizard** can then be closed by clicking **Finish** or you can click the link, such as **C:\My Photos\Castles** (in the example shown below) to go straight to the folder containing the newly copied photographs.

The photographs are now saved on your hard disc in the selected folder. In the example below I have copied some photographs into the newly created **Castles** folder.

In the above example, with the photograph shown in the **Thumbnail** view, (discussed later), the name of the file **castles 001.jpg**, was allocated automatically after the group name of **castles** was entered. To make the name of the photograph more meaningful it could be renamed with a title such as **Visit to Conway Castle June 2003.jpg**. (Microsoft Windows will accept long file names like this.)

Right-click over the thumbnail or icon for the photograph and select **Rename** from the menu which appears. Then simply type in the new name to replace the old one, as shown on the right. Various options for viewing and managing photographs on your hard disc are covered in later chapters.

Using Software Supplied with the Camera

This section shows how images can be downloaded from a digital camera to a computer, using software provided with the camera. In this example, I am using the CAMEDIA software supplied with new Olympus digital cameras. Like most software nowadays, installation is achieved by simply inserting the CD in the drive and then following the instructions which appear automatically on the screen.

During the process of installing the software you may be asked to enter a *serial number* or *product code* for your CD. This is usually a long string of letters and numbers on the back of the CD or its packaging. After the software is installed, put the CD away in a safe place. Make sure also to save the serial number or product code. If any snags arise you may need to repeat the software installation process at some point in the future.

After installation, the program can be launched by clicking **start**, **All Programs** and then the program name, in this case **OLYMPUS CAMEDIA** and **CAMEDIA Master**, as shown below.

Please note above that apart from the **CAMEDIA Master** program itself, there is also a **Help** feature, a **ReadMe** file and a comprehensive **Reference Manual**.

When you launch the **CAMEDIA Master** program, the screen shown below is displayed.

To start the download process, make sure the camera is connected to the computer by the USB cable, then click the icon for **Get Images From Camera** as shown above. First the software detects the digital camera. Then a screen appears, as shown on the next page, displaying a grid of thumbnail images representing the photographs stored in the memory of the camera. There are radio buttons allowing you to highlight **All images** or **Selected images**. You can select a block of images by holding down the **Shift** key while clicking the left mouse button. Multiple images scattered around the grid can be selected by holding down the **Ctrl** key while clicking the image with the mouse.

When you have selected the images to be copied to your computer, select the destination folder on your hard disc.

This is done by highlighting the folder in the right-hand panel of the screen, under **Media** shown below. There is also a button to allow you to create a **New Folder** in which to store the photographs, shown at the bottom right below.

Click the **Get Images** button shown in the centre below and the selected photographs are copied to the specified folder.

You can view the photographs copied to your hard disc by selecting **Browse Images** from the main **CAMEDIA Master** screen shown on the previous page.

3 Downloading Images to a Computer

The screen display now shows the thumbnail photographs down the centre and right of the screen and the folders down the left-hand side under **Media**.

Along the top of the **CAMEDIA Master** screen there is now a menu bar, as shown below. The **CAMEDIA Master** menu bar includes options to display the **Properties** of the photographic file and to **Rotate** images (through 90 or 180°). You can also **Edit**, **File** and **Print** the photographs.

Most of these features are discussed later in this book, but briefly **Edit** allows the photographs to be cropped, resized, rotated and text added. There is a **Filter** option to adjust the brightness, colour balance and red-eye effect of the image.

Using a Memory Card Reader

The memory card reader is a separate device, about the size of a small matchbox, which plugs via a cable into one of the USB ports on the computer. The advantages of a separate memory card reader are:

- The card reader takes its power off the USB port, so doesn't run down the batteries in the camera. Low batteries could cause problems during the downloading of photographs.

- The camera is not tied up while the memory cards are being read into the computer.

A Belkin USB Media Reader and Writer, for example, can be bought for under £20, at the time of writing. Different versions are available for various brands of memory card, as shown below.

As mentioned earlier, if you don't have a USB port or they are all used up by USB devices, you can either:

- Have some USB ports fitted at a local computer shop.
- Plug a USB hub or adapter into an existing USB port. This will give 2, 4 or more USB sockets.

The USB card reader is claimed to be up to 40 times faster for transferring data than a device which uses the *serial port*. The serial ports are sockets on the back of the computer, previously a common method for connecting mice, modems and cables for data transfer, before the arrival of USB technology.

The card reader acts like another disc drive, allowing photographs to be dragged and dropped into folders of your choice. This can be done in **My Computer** or the **Windows Explorer**, discussed later. You can also copy photographs from a folder on your hard disc back to the memory card.

The card reader can be used to *format* a memory card. This process is sometimes needed to prepare a new memory card for use. (Memory cards supplied by the manufacturers of your camera should have been already formatted when you buy them.)

The Belkin package includes the media reader/writer, a user manual and a software CD. Apart from the installation program for the memory card reader, the CD also includes the popular Ulead Photo Express digital editing software.

Installing the Software for the Memory Card Reader

The CD is placed in the drive and starts up automatically. The installation screen shown on page 41 appears, from which you click your particular type of storage, in my example the SmartMemory card. It is then simply a case of following the instructions on the screen. At the end of the installation process, the computer is restarted.

As the memory card reader is a USB device it can be "hot swapped", i.e. you can connect it to the USB port while the computer is up and running. The Windows operating system should immediately display the message **Your new hardware is installed and ready to use**.

Before inserting your memory card into the reader, you need to check with your instruction manual for the correct orientation of the card. Next insert the memory card.

Now select **My Computer** from the **start** menu. The card appears as a removable disc **(E:)**, as shown right and below.

SmartMedia (E:)

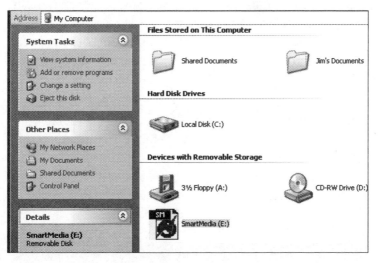

Address: My Computer

System Tasks
- View system information
- Add or remove programs
- Change a setting
- Eject this disk

Other Places
- My Network Places
- My Documents
- Shared Documents
- Control Panel

Details
SmartMedia (E:)
Removable Disk

Files Stored on This Computer
Shared Documents Jim's Documents

Hard Disk Drives
Local Disk (C:)

Devices with Removable Storage
3½ Floppy (A:) CD-RW Drive (D:)

SmartMedia (E:)

Double-click the icon for memory card **(E:)** and open up the folder containing the photographs in **My Computer**. The photographs, still on the memory card at this stage, are displayed in thumbnail view, as shown below.

Now the photographs can be selected by clicking with the mouse and copied by "dragging and dropping" to a folder of your choice. You can select multiple images by holding down the **Shift** key or the **Ctrl** key while clicking the image with the mouse. Once copied to a folder on your hard disc, the photographs can be renamed, organized into subfolders and edited, enhanced and deleted, as described later.

Before removing the memory card, *right-click* over its icon in **My Computer**. Then select **Eject...** from the menu which appears. It will then be safe to remove the memory card. Before disconnecting the memory card reader, click the **Safely Remove Hardware** button on the right of the Windows Taskbar, as shown on the extreme right below.

Scanning Photographic Prints

Old photographs, even if they are quite tatty, can be scanned and stored on your computer. Alternatively someone who uses a traditional film camera to produce prints can use a scanner to enjoy the many benefits of digital photography. Once images are safely stored on your hard disc they can be enhanced in a digital image editing package like Paint Shop Pro or Adobe Photoshop Elements. Enhancing old photographs might include removing scratches or other damage which has occurred over the years. You might then want to copy the photographs to a CD for archiving in a more secure form, as discussed elsewhere in this book.

A4 *Flatbed* scanners, where the photograph is placed face downwards on a sheet of glass, are popular for general use and can be bought for about £50 upwards. Some scanners include a built-in Transparency Unit enabling 35 mm slides and negatives to be scanned. One of the popular Epson Perfection scanners is shown below.

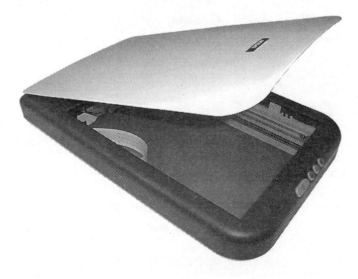

3 Downloading Images to a Computer

Various scanning tasks can be carried out on photographs (and also other documents) up to A4 size and include:

- Copying and printing a photograph directly.
- Saving a photograph in a folder of your choice.
- Importing a photo into a digital editing program.
- Sending a photograph to a Web site.
- Sending a photograph to be included with an e-mail message, as an attachment.

The Epson scanner is started from the **All Programs** menu and the **Epson Smart Panel** is launched as shown below.

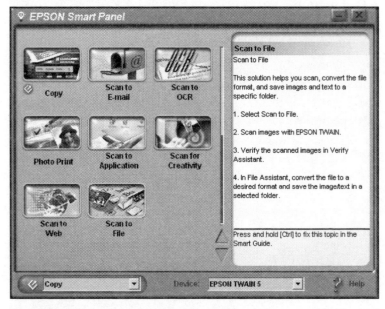

There is a setting to specify either colour or black and white photos. Resolution is set at 300 d.p.i. by default, with a range of 50-7600 d.p.i available. In this example an image is being scanned then saved on the hard disc, so **Scan to File** is selected.

Shortly a window appears showing a thumbnail view of the document being scanned, with a default **File Name**. This can be altered to a name of your choice, as shown on the right.

On clicking **Finish** you can select **Browse** and then choose the folder in which to store the scanned image as shown below. In this case **C:\My Photos** has been selected. Clicking the **Save** button shown below places a copy of the scanned image on your hard disc.

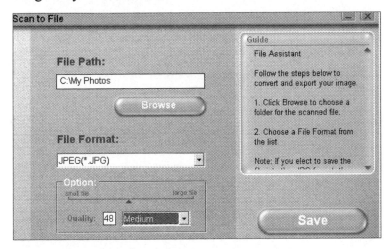

The **File Format** entered above is particularly important in photographic work, since image files can be extremely bulky in certain formats. The **File Format** is selected from the drop-down menu shown on the next page.

When saving photographs, the **JPEG (*.JPG)** format shown below is very suitable. This saves the photos in a compact format without any obvious loss in quality. File types for photographs are discussed in more detail on pages 142-144.

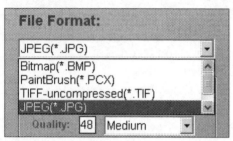

As discussed in Chapters 9 and 10 of this book, digital editing programs like Paint Shop Pro and Photoshop Elements can import images directly from a scanner. Most scanners use a standard piece of software called a *TWAIN driver*. Unlike many computing terms, TWAIN is not an acronym. Its meaning derives from the TWAIN driver's role as the link between the scanning device and the computer - "never the twain shall meet". Programs such as Paint Shop Pro and Photoshop Elements are designed to support the TWAIN standard. To scan an image and open it for editing in a program like Paint Shop Pro, select **File**, **Import**, **TWAIN** and **Acquire** from the menu bar.

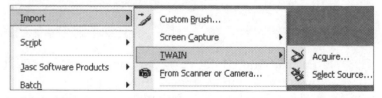

Adobe Photoshop Elements and Paint Shop Pro have a **Straighten** feature to remove the effect of a photographic print which is placed slightly skewed in a flatbed scanner.

4

Viewing Photos in Windows XP

Introduction

Windows XP, the latest in the series of Microsoft Windows operating systems, includes a number of features to enable the viewing and management of photographic files. If your computer uses a different operating system, there are several alternative software packages from other companies which can be used to view and manage your photographs. These include Adobe Photoshop Album, discussed later.

Windows Explorer, part of Windows XP, includes the following features for viewing digital photographs:

- A *slideshow* in which each photograph occupies the whole screen and the photos are changed automatically or under the control of the user.

- *Thumbnails*, where all of the photographs in a folder are shown as miniatures arranged in a grid.

- A *filmstrip* where all of the photographs are shown as thumbnails in a line along the bottom of the screen, with the currently selected photo shown enlarged above.

The **Windows Picture and Fax Viewer**, discussed shortly contains a number of features to assist with viewing.

To launch Windows Explorer, *right-click* over the **start** button on the Windows Desktop, then select **Explore** from the resulting menu, as shown on the right.

| Open |
| Browse With Paint Shop Pro 7 |
| Explore |
| Search... |
| Scan with Norton AntiVirus |
| Properties |
| Open All Users |
| Explore All Users |

From the left-hand panel in Explorer shown below, select the folder in which you have saved the photographs. In this example, three photographs were saved in the folder **Castles**, within the folder **My Photos** on the **C:** drive, shown below. (The **C:** drive is the computer's hard disc.) So the full *path* for the location of the photographs within the folders on the hard disc is **C:\My Photos\Castles**. The path is displayed in the **Address:** bar at the top of the Explorer window, as shown below.

There are several ways to display your photographs and related information, in the Windows Explorer. For example if you want the left-hand side of the screen to show the folders on your hard disc, then select **View, Explorer Bar** and ensure **Folders** is ticked, as shown below on the right.

The tick can be removed by clicking over the word **Folders** in the above menu. If there is no tick next to **Folders** the following two menus, discussed later, appear vertically down the left-hand side of the screen, instead of the folders.

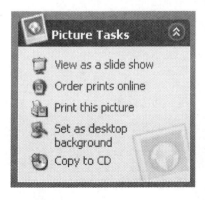
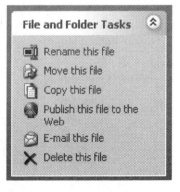

Filmstrip View

The **View** menu in Windows Explorer shown below allows the photographs to be displayed in several different arrangements, such as **Filmstrip**, **Thumbnails** and **Tiles**, etc.

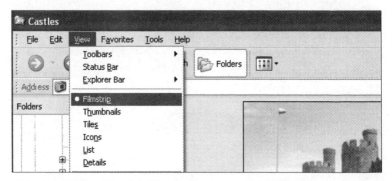

The **Filmstrip** view, as shown below, enables you to scroll through enlarged versions of each photograph one at a time, with the thumbnail or miniature versions below.

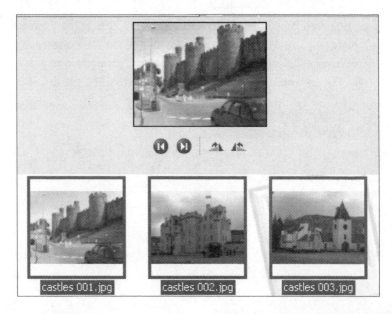

Note in the **Filmstrip** view shown previously, you can scroll through the pictures using the control buttons shown on the right. The next two icons rotate the images clockwise or anticlockwise in steps of 90 degrees.

Apart from **Filmstrip**, there are several other options for viewing your photographs in the Windows Explorer, as shown on the **View** menu below. The other options are **Thumbnails**, **Tiles**, **Icons**, **List** and **Details**.

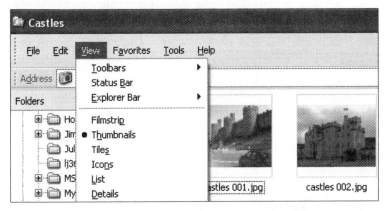

The screenshot above shows the photographic files displayed in miniature in the **Thumbnails** view. If the **Tiles** view is selected from the above menu, each photo is represented by a picture icon. Details are given for the resolution (**1600x1200**) and the type of file (**Paint Shop Pro** in this example).

The **Icons** and **List** views from the above menus cause the photographs to be arranged in rows and columns respectively, with each image represented simply by a small icon and the file name.

If you want to find out more about your pictures, select
View and **Details** from the Explorer menu bar shown along
the top of the previous screenshot. The Explorer window
now shows the **Size** of each photographic file, e.g. **426 KB**.

C:\My Photos\Castles				
Name ▲	Size	Type	Date Modified	Dimensions
castles 001.jpg	426 KB	Paint Shop Pro 7 Im...	24/06/2003 18:16	1600 x 1200
castles 002.jpg	427 KB	Paint Shop Pro 7 Im...	24/06/2003 18:16	1600 x 1200
castles 003.jpg	422 KB	Paint Shop Pro 7 Im...	24/06/2003 18:16	1600 x 1200

Also shown under the **Type** heading is the name of the
digital editing program **Paint Shop Pro 7**, which can be
used to open and edit photographs (discussed later in this
book). A further column shows the date when the files for
the images were created or modified on the hard disc. The
numbers listed under **Dimensions** are the resolutions of the
photographs, in this case **1600x1200** for all of the photos.

Viewing Photographs as a Slide Show

The **Picture Tasks**
menu displayed as
shown right and on
previous pages,
includes an option **View
as a slide show**. If you
can't see the **Picture
Tasks** menu in the

Windows Explorer, select **View**, **Explorer Bar** and click
Folders to remove the tick. Selecting **View as a slide show**
causes the photographs to be displayed in a revolving
sequence, occupying the entire screen. The slide show is
discussed later in the next section describing the **Windows
Picture and Fax Viewer**.

Using the Windows Picture and Fax Viewer

If you double-click the icon or thumbnail for an image in the Windows Explorer, this starts up the **Windows Picture and Fax Viewer,** as shown below.

The menu bar along the bottom of the screenshot above contains a number of useful buttons for displaying and managing photographs.

The first two buttons allow you to scroll through the photographs by selecting the next or previous image.

Working from left to right, the next three buttons show the image as a **Best Fit**, **Actual Size** or as part of a **Slide Show**. In the **Slide Show**, each image fills the whole of the computer screen, as shown below.

Each image is displayed for a few seconds before the next one appears automatically. If you move the mouse during the slide show, some control buttons appear allowing you to pause, start and stop the slide show and to select the next or previous images. If you press the **Esc** key you are returned to the **Windows Picture and Fax Viewer** with the menu bar along the bottom, as shown on page 55.

The next two buttons on the **Windows Picture and Fax Viewer** menu bar allow you to **Zoom in** and **Zoom out** of the image.

The two icons shown on the right enable the image to be rotated **Clockwise** and **anti-clockwise**, in steps of 90 degrees.

The next icon on the **Windows Picture and Fax Viewer** menu bar, shown in full on page 55, allows you to delete the currently selected photograph or image file. This topic is discussed in more detail in the next chapter.

You can print the current image using the next icon on the menu bar, shown on the right. This launches the **Photo Printing Wizard**, discussed later in this book. The wizard guides you through the process of printing a photograph in different formats, e.g. 2 to a page or 4 to a page, etc.

The next icon is for copying a photograph to another folder on your hard disc or perhaps to a floppy disc or CD if you want to give someone else a copy. The **Copy To** dialogue box appears, as shown below, allowing you to select the destination for the copy.

![Copy To dialogue box. Save in: Family Photos. Folder list shows My Recent Documents, Desktop, My Documents, My Computer, 3½ Floppy (A:), Local Disk (C:), Family Photos (highlighted), CD-RW Drive (D:), SmartMedia (E:), Shared Documents, My Documents, My Network Places, Unused Desktop Shortcuts. Files: Wedding.jpg, P1010027.JPG, Riding.jpg. File name: P1010031. Save as type: JPEG. Buttons: Save, Cancel.]

Referring to the **Windows Picture and Fax Viewer** menu bar shown on page 55, the icon on the right closes down the picture viewer and opens up a digital image editing program, displaying the current photograph ready for editing. In this example the image has been opened up in Paint Shop Pro, as shown below.

Editing photographs is discussed later and involves altering and enhancing images by changing the brightness, colour balance, etc., and removing unwanted features. If you want to open the photograph in a different program which has been installed on your hard disc, *right-click* over the icon (shown right), select **Open With** and then choose the required program from the menu.

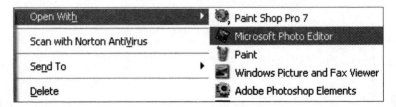

5

Managing Photos in Windows XP

Introduction

The Explorer feature in Microsoft Windows XP allows you to carry out a number of management tasks to help with the efficient organization of your photographs, stored as *files* in *folders* and *subfolders* on the computer's hard disc.

Management tasks include the following:

- *Deleting*, from the hard disc, photographs which are no longer needed.

- *Renaming* photographs with easily recognizable names.

- *Copying* and *moving* photos between different folders.

- *Creating folders*, including *album folders*, with meaningful names, enabling photographs to be organized into recognisable categories.

- *E-mailing* photographs to a friend, relative or business contact

- *Publishing* photographs on a Web site where others can see them.

E-mailing and publishing photographs to a Web site are discussed later in this book.

File and Folder Tasks

Start the Windows Explorer by *right-clicking* over the **start** menu and selecting **Explore** from the menu which pops up. Now select the folder containing your photographs. The folders down the left-hand side of the Explorer window can be replaced by the **Picture Tasks** and **File and Folder Tasks** menus shown on the left below. To do this select **View**, **Explorer Bar** and make sure there is no tick next to the word **Folders**.

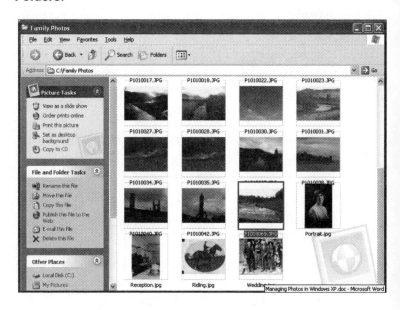

Now select one of the photographs in the right-hand panel shown above. The **File and Folder Tasks** menu extends to reveal the full list of options shown above on the left and also on the next page.

Renaming a Photograph - Meaningful File Names

When you download a batch of photographs from your camera, the whole batch is saved with a group name such as **castles**, for example, which you provide. Individual photographs are distinguished by a number, such as **001**, **002**, **003**. So for example, I downloaded and saved three photographs with the names **castles 001.jpg**, **castles 002.jpg** and **castles 003.jpg**. Please also note that the numbers **001**, **002**, **003** and the file name extension **.jpg** are all added automatically. As discussed earlier, the **.jpg** extension denotes that the file has been saved in the **JPEG** format, a common system for saving photographs.

Obviously it's preferable to give individual photographs a more meaningful name, so we might, for example, wish to change **castles 001.jpg** to something like:

Visit to Conway Castle June 2003.jpg

To change the name of the photograph, select the image in Windows Explorer and click **Rename this file** from the **File and Folder Tasks** menu shown right. The new file name can now be typed in to replace the old one, as shown below.

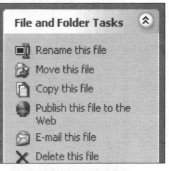

Moving and Copying Photographs

Referring to the **File and Folder Tasks** menu shown on the previous page, **Move this file** enables you to transfer a photograph to another folder which you have selected, removing it from the original location. **Copy this file** places a duplicate in another folder which you have selected, leaving the original photograph in the original folder.

Both the **Move** and **Copy** options result in a destination window appearing. Only the **Move Items** window is shown below, but the **Copy Items** window is very similar. These two windows allow you to choose a destination folder on your hard disc (or perhaps a floppy disc or CD) into which the photograph is to be moved or copied. Then click **Move** or **Copy** to complete the operation. There is also a button, as shown below, giving you the option to make a new folder into which to move or copy the photograph.

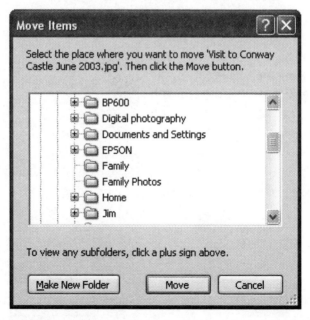

Moving Photographs by Dragging and Dropping

We can move any photographs, which may have been downloaded and saved in a disorganized fashion, into a more appropriate folder. For example, I have a photograph of a mallard, saved along with a lot of other photographs and given the name **scotland 016.jpg**. It is currently in a folder called **Highlands** and I want to move it to my **Scotland** folder, a subfolder of the **Holidays** folder. We could carry out the operation to move the photograph using the **File and Folder Tasks** menu discussed on page 62. However, another popular method is to "drag and drop" the files between different folders displayed in the Windows Explorer.

First the Windows Explorer is opened, with the thumbnail for the photograph visible in the right-hand panel, as shown below. The folder containing the photograph, **Highlands** is shown in the left-hand panel of Explorer. Also shown in the left-hand panel is the folder **Scotland**, into which the photograph is to be moved.

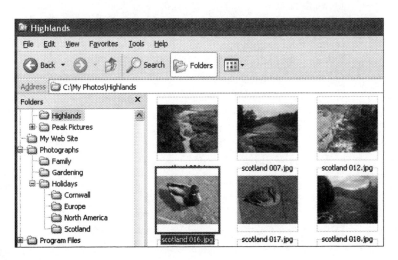

To move the photograph to its new folder, select the thumbnail (or the icon, depending on the view selected), then, keeping the left mouse button held down, drag the thumbnail or icon and drop it over the destination folder. As you drag a picture over the destination folder, the folder name should become highlighted. Then you can safely release the left mouse button to drop the picture into the correct destination folder.

There are further options for the dragging and dropping operation. For example, if the *right* mouse button is held down to drag the photographic file, on releasing the button, a menu appears, giving you the choice to either **Copy Here** or **Move Here**, as shown below at the bottom right.

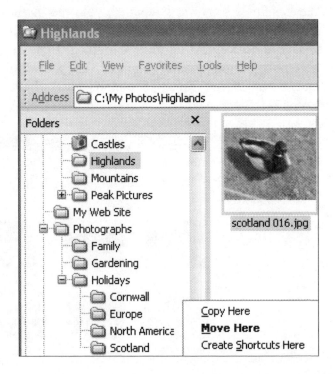

After the move or copy operation, the photograph will now be in its new folder, **Scotland**, as shown below, having been moved from the **Highlands** folder.

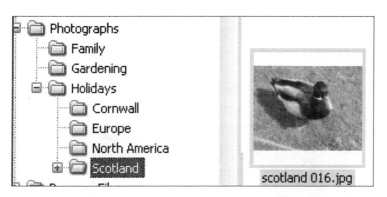

The photograph might also be renamed with a more meaningful name, such as **Mallard in Braemar.jpg**. This can be done using the **Rename this file** option on the **File and Folder Tasks** menu discussed earlier in this chapter. Alternatively *right-click* over the icon for the file and select **Rename** from the menu which appears.

Deleting a Photograph

Referring to the **File and Folder Tasks** menu, shown on page 61, **Delete this file** doesn't actually remove a selected photograph from you hard disc. In fact, all "deleted" files are simply moved to a special Windows folder called the **Recycle Bin**. Files are not deleted until you give the instruction to *empty the recycle bin*. (Right-click over the icon for the **Recycle Bin** on the Windows Desktop then click **Empty Recycle Bin** as shown below.)

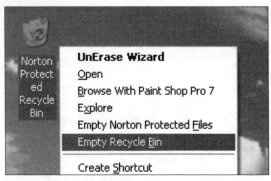

That completes the options of renaming, moving, copying and deleting files on the **File and Folder Tasks** menu. The options to publish photographs on the Web and e-mail photographs are discussed later.

As with many tasks in the Windows operating system, there are several different ways of achieving the same result. For example, instead of using the **File and Folder Tasks** menu shown previously to carry out operations such as deleting or renaming files, you could use the **File** menu off the Explorer menu bar, after first selecting the required photograph in the right-hand panel of Explorer.

Context-sensitive Menus

A useful feature in Microsoft Windows is the ability to launch *pop-up menus* which are relevant to the currently selected object on the screen. This is achieved by *right-clicking* over the object. For example, if you *right-click* over the file name or thumbnail for a photograph in the Windows Explorer, as shown below, a menu appears listing the many operations which can be performed on photographic files. This is much more comprehensive than the **File and Folder Tasks** menu shown previously.

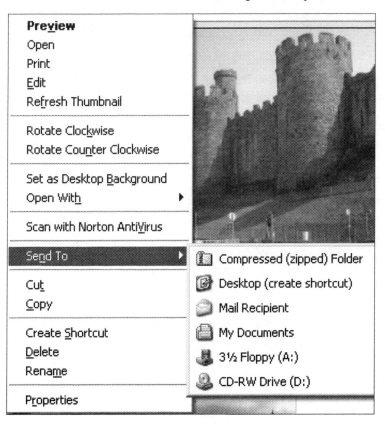

Referring to the previous menu, you can see that the usual file management tasks can be performed, such as **Cut, Copy, Delete** and **Rename**. **Cut** removes a selected photograph from one location and allows it to be *pasted* into another. **Copy** makes a duplicate of a photograph which can be pasted into a new location, using the **Edit/Paste** option on the Explorer menu bar.

The **Send To** option shown on the previous menu can be very useful, since, among other things it provides an easy method to copy photographs to a floppy disc, CD-R or CD-RW. You can also e-mail them to a **Mail Recipient**. These topics are discussed later in this book.

The Properties Dialogue Box

If you select **Properties** from the previous menu, full details are given for the photographic file, as shown on the next page. These include the name of the **JPEG** or **.jpg** file, its **Location** within the folders on the hard disc, also known as the *path*, and dates created, modified and accessed. **Opens with** refers to the program which can be used to open the file. In this example, the **Windows Picture and Fax Viewer** is listed, but this could be changed to another program using the **Change** button provided.

The **Size:** entry, **406KB** is of considerable significance here, since this shows how bulky a file for just one photograph can be. This should be borne in mind if disc space is an issue on your computer. Also, if you are e-mailing a photograph to a friend or relative using traditional modems, large photographs are very slow to send and download.

Switching on the **Read-only** attribute above should ensure that a photograph cannot be accidentally deleted. Switching on the **Hidden** attribute can be used to stop the photographic file being listed in the Windows Explorer.

Organising Photographs in Folders

When Windows XP is installed on a computer, a special folder called **My Pictures** is created within the folder **My Documents**. This contains a *subfolder*, **Samples**, with some examples of digital photographs.

Initially you may wish to save all of your photographs within the folder **My Pictures**, or **C:\My Documents\My Pictures** to use the full path name. However, it's useful to be able to organize your photographs into your own *hierarchy of folders and subfolders*. This will allow you to sort photographic files into different categories, just as you might put traditional photographic prints into different albums.

So you might, for example, create folders on your computer for **Family**, **Holidays** and **Gardening**.

A folder can be divided into a number of *subfolders*, so that the **Holidays** folder might contain folders for **Scotland**, **Cornwall, Europe** and **North America,** for example. Once your photographs are organized into folders, apart from being easier to locate particular images, it is also easier to copy, move, delete, print or e-mail groups of photographs.

First let's create a folder called **Photographs**, then subdivide it into **Family, Holidays** and **Gardening**. Then the **Holidays** folder will be divided into **Scotland, Cornwall, Europe** and **North America**. The folders will be created on the **C:** drive or hard disc, so the organization of the folders might be something like:

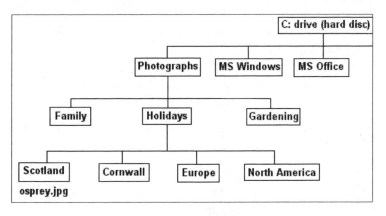

If a photographic file called **osprey.jpg**, were saved in the **Scotland** folder as shown above, the full path to the file through the hierarchy of folders on the hard disc would be:

C:\Photographs\Holidays\Scotland\osprey.jpg

Creating a New Folder

Start the Windows Explorer by *right-clicking* over the **start** button and selecting **Explore**. If the folders are not displayed in the left-hand panel as shown on the right, select **View, Explorer Bar** and click the word **Folders** to display a tick.

Highlight the entry for the Local Disk (**C:**) as shown on the right. Now select **File, New** and **Folder** from the Explorer menu bar. An icon for a folder appears in the Explorer right-hand panel, with the words

New Folder alongside. Replace the words **New Folder** with the name of the folder you are creating, in this example, **Photographs**.

Now use the same method to create the subfolders **Family, Holidays** and **Gardening** within the **Photographs** folder. First highlight the new folder, **Photographs**, in the left-hand panel of Explorer. Then for each new folder, select **File, New** and **Folder** from the Explorer

menu bar and enter the name of the new folder.

In the same way, select **Holidays** in the left-hand panel and then create the subfolders **Scotland, Cornwall, Europe** and **North America.**

This should have created the folders structure shown in the diagram on page 71. The same structure, in the form of folders, is shown below in the Windows Explorer.

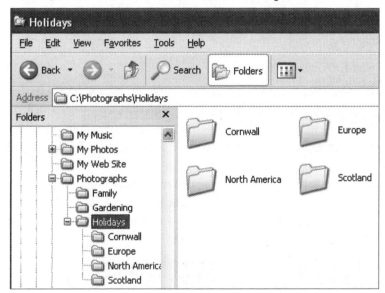

Please note that another way to create a new folder within a folder that is already open is to select **Make a new folder** from the **File and Folder Tasks** menu shown on the right. To display this

menu in the Windows Explorer select **View, Explorer Bar** and make sure **Folders** is not ticked.

The **New Folder** icon will appear alongside of the existing folders, ready for you to enter your chosen name for the folder.

Photo Album Folders

If your new folder is going to be used exclusively for saving photographs, it can be designated as a **Photo Album** folder. This will ensure that all of the menu options for photographic files are available. With the folder displayed in the Windows Explorer, *right-click* over the folder's name or icon. Then select **Properties** from the menu which appears. After clicking the **Customize** tab shown below, you can change the folder type from the drop down menu under **Use this folder type as a template**.

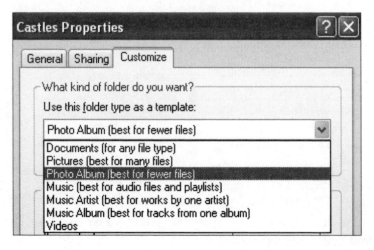

After selecting **Photo Album (best for fewer files)**, there are options to **Also apply this template to all subfolders**, as shown below. You can also use **Choose Picture...** to put an image on the front of a folder to remind you of the contents, as shown under **Preview** below. This is displayed when Explorer is set in thumbnails view, i.e. by selecting **View** and **Thumbnails** off the Explorer menu bar.

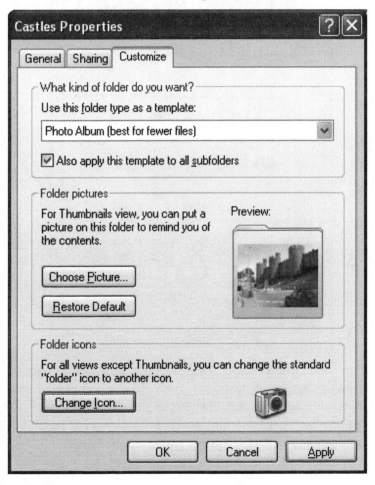

For all views other than **Thumbnails** you can use **Change Icon...** shown previously to replace the normal folder icon. When you click the **Change Icon...** button you are presented with a choice, as shown below. In this example, I chose to represent the folder by a camera icon, as shown below and on the previous **Properties** dialogue box.

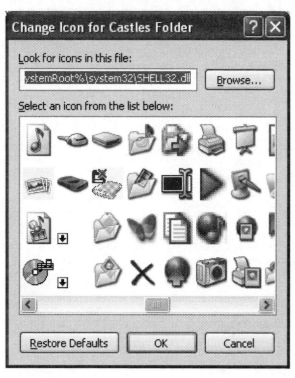

Once you have created your own hierarchy of folders in different categories, you can move your photographs into the new folders using the Windows Explorer. Various methods are available for moving photographs including the **File and Folders Tasks** menu and "dragging and dropping", both described earlier in this chapter.

Archiving Photos to Compact Disc

Introduction

Imagine losing a collection of photographs recording some of the most important events in your life - priceless reminders of people and places and special events such as weddings, anniversaries, holidays and celebrations. With a digital camera hundreds of photographs can soon be accumulated - you can easily acquire over a hundred images in your memory card during a short trip or holiday.

Unfortunately disaster could strike if the only copies of the images are on the hard disc inside of your computer. Photographs stored in this way cannot be considered secure for the long term, for the following reasons:

- Your computer or hard disc may develop a fault which requires the hard disc to be wiped.
- Someone may accidentally delete the folders containing the photographs.
- You may decide to buy a new computer.
- The computer may be stolen or damaged by fire.

Fortunately it's easy to copy your entire record collection onto a Compact Disc, where the images will be safe for many years to come. In fact, the CD is more robust than traditional prints, which may become faded and scratched.

Media for Archiving Photographs

To secure your photographic collection for the long term, the photographs should be copied to a separate storage medium, typically some form of removable disc, such as a CD (Compact Disc).

A photograph saved as a file on disc takes up a huge amount of space, often 500 kilobytes or more. The humble floppy disc is therefore not suitable as it can only hold one or two photographs saved at high resolution. (Although you might use a floppy disc if, for example, you wanted to give someone a copy of a single photograph).

One solution for backing up photographs might be the *ZIP disc*. This is a removable hard disc which has its own external disc drive, connected to the computer by cables. Zip discs originally stored 100MB of data, but 250MB and 750MB versions are also available now.

However, probably the cheapest and most efficient backup medium for photographs is the Compact Disc. There are two basic types of CD, the CD-R and the CD-RW.

- The *CD-R* can only be written to once, but as it is very cheap you can afford to make lots of backups. When bought in packs of 50 a CD-R can cost as little as 20 pence or less. One CD-R can store 700MB of data files or hundreds of photographs. The CD-R is an excellent backup medium for archiving a photographic collection as it has a large capacity, it's very cheap and is extremely durable and reliable.

- The *CD-RW* is similar to the CD-R except that it can be written to many times. Currently a single CD-RW costs upwards of £1.

CD-RW Drives

Most new computers now have a built-in CD-RW drive capable of "writing" or "burning" CDs. This is the process of copying data files (such as photographs) onto CD-Rs and CD-RWs.

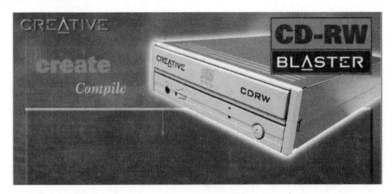

If your computer doesn't have a CD-RW drive, one can be bought separately for about £40 upwards, depending on the speed of operation. The performance of a CD-RW drive is normally quoted as 3 numbers, such as **52x24x52**. These represent the speed when *writing*, *rewriting* and *reading* CDs. **52x24x52** means that this particular CD-RW drive has the following performance :

Writes at 52 speed

Rewrites at 24 speed

Reads at 52 speed

40x12x40 drives are also available and I'm still getting good use out of an earlier **24x10x40** drive. However, as with most computing equipment, it's a good idea to buy the most powerful CD-RW drive you can reasonably afford in order to keep up-to-date with the latest developments.

CD Writing Software

Earlier versions of Microsoft Windows did not include CD "writing" or "burning" software, so it was necessary to purchase a third-party product. Two of the most popular third-party packages, currently costing under £40, are Easy CD Creator from Roxio and Nero from Ahead Software.

If your computer uses Windows XP then you already have some excellent built-in CD burning software. The software built into Windows XP, discussed shortly, is a version of the Roxio CD burning software and is an extremely useful and reliable backup tool. I have been using this software for backing up data files for nearly two years, without a single problem in the CD writing process. Perhaps more importantly, there has never been a problem in recovering the backed-up files from the CD back to the computer.

If your computer does not use Windows XP, one option is to install the popular Nero package. This provides a *wizard* which guides you through the process of selecting files from your hard disc and copying them to the CD.

Using Windows XP's Own CD Burning Software

Open **My Computer** and double-click the hard disc drive (**C:**) icon to display the folders. Alternatively *right-click* the *start* button, click **Explore** and locate the required folder in the Windows Explorer. In the example shown below, the required photographs are in the **Family** folder. Make sure the **File and Folder Tasks** menu is visible in the left-hand panel, as shown below. If the **File and Folder Tasks** menu is not visible, select **View, Explorer Bar** and make sure there is no tick next to the word **Folders** on the menu which appears. (Click the word **Folders** to either add or remove the tick).

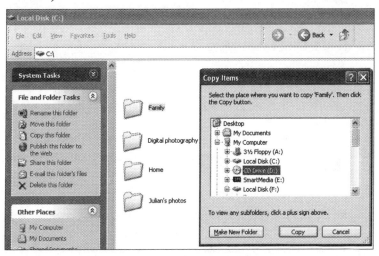

Now select the folder containing the photographs in My Computer or the Windows Explorer. Then select **Copy this folder** from the **File and Folder Tasks** menu as shown in the left-hand panel above. The **Copy Items** dialogue box appears, as shown above on the right, from which you select **CD Drive (D:)** as the destination for the copied folder.

Another way to copy the folder to a CD is to *right-click* over the folder in My Computer or the Windows Explorer. The following menus appear, as shown below.

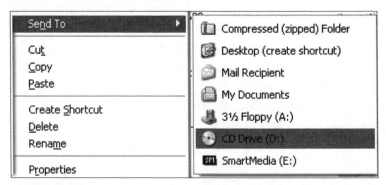

Click the **Send To** option and then select **CD Drive (D:)** as the destination, as shown above.

The files to be copied to the CD are first copied to an *image file* on your hard disc, prior to copying to the CD. A note appears in a "balloon" at the bottom right of the screen as shown below.

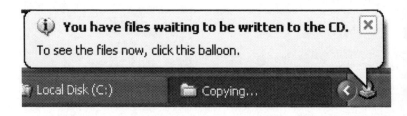

On clicking the balloon shown above, the **CD Writing Tasks** menu appears as shown on the next page.

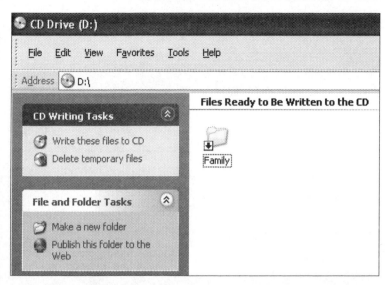

Now highlight the folder (**Family** in this example) and select **Write these files to CD** from the **CD Writing Tasks** menu shown on the left-hand panel above. This starts the **CD Writing Wizard** shown below, where you are able to give a name to the CD (if you don't want to use the default name supplied).

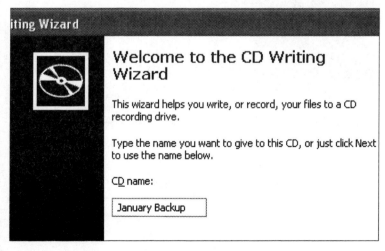

After clicking **Next** a window appears showing the progress being made in the copying process.

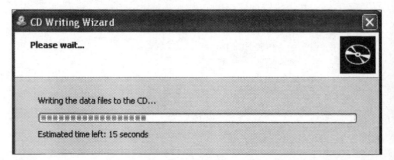

After the files have been copied, a window appears (all being well) telling you that the process has been successful.

Please also note in the above dialogue box, there is an option to create another CD using the same files. This would be useful either as an additional backup copy or perhaps to give to a friend or relative so that the photographs could be viewed on their computer.

Recovering Photographs from a CD

Once your photographs are safely stored on one or more CDs, they should be secure for many years to come. It's a good idea to check that the backup process was successful by trying to recover a few photographs from the CD.

You can see what files are on the CD in My Computer or the Windows Explorer. Click *start* and **My Computer** then double-click the icon for the CD drive as shown on the right below.

The Windows Explorer opens, displaying first the folder containing the photographs. Double-clicking over the folder reveals a list of the actual photographs. In the example below, the photographs are shown after **View** and **Details** have been selected from the Explorer menu bar.

It can be seen from the previous screenshot that the 7 photographs copied totalled less than 3MB, making very little impression on the 700MB capacity of the CD.

Double-clicking a photograph in Windows Explorer opens up the image in the *associated program*. This might be the Windows Picture and Fax Viewer or a program such as Adobe Photoshop Elements or Paint Shop Pro.

A full range of viewing options, as discussed in Chapter 4, such as *thumbnails* and *slideshow* are available for the photographs stored on the CD. These are obtained by selecting the **View** menu in Windows Explorer.

You can also open a photograph in a program like Adobe Photoshop Elements or Paint Shop Pro, for example, by clicking **File** and **Open...** and selecting the CD. Then open the folder (**Family** in this example) to select and open the required photograph ready for digital editing, etc.

Archiving Using Adobe Photoshop Album

The previous section described the copying of photographs to a CD using the CD "burning" software built into Microsoft Windows XP. The program Adobe Photoshop Album, discussed in the next chapter, has many features designed to facilitate the organizing and management of photographs. These include an option to *archive* your photographs, accessed by clicking **File** and **Archive....**

You are given the opportunity to supply a name for the archive set of photographs, as shown below.

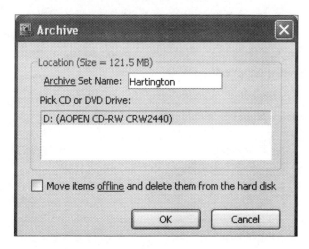

Please note in the previous screenshot, there is an option **Move items offline and delete them from your hard disk**. This option is particularly useful if your hard disc is getting full and there are lots of photographs you don't use very often. Using this option the original high resolution photographs are written to the CD and deleted from the hard disc. A low resolution copy of each photograph is retained on the hard disc. Later, this low resolution version can be viewed on the screen, but for printing purposes the high resolution version of the file will need to be retrieved from the CD.

After you click **OK** you then confirm that you would like to burn the first disc.

Then the process of archiving or copying the photographs to the CD begins. You are informed of progress as the archiving proceeds.

When the archive is complete, you are given the chance to *verify* the archive CD. This checks that the photographs have been copied correctly.

After clicking **Verify**, the checking process takes a minute or two before you receive a message, all being well, confirming that the archive was successful.

Labelling and Storing Your CDs

You will soon accumulate a large collection of CDs containing photographs. These should be stored in a secure place and clearly labelled with the date and meaningful titles to enable you to identify them easily.

Retrieving Photographs from a CD

When you want to view or print the photographs archived on a CD, select **Get Photos** from the Photoshop Album shortcut bar or from the **Quick Guide**. Then click **From Files and Folders...** and select the CD drive from the files, folders and discs listed in the **Look in** bar, as shown below.

Please note in the above window, there is an option **Keep Original Offline**. If this option is selected, a low resolution or *proxy* version of the photograph(s) is downloaded to your computer from the CD. If the **Keep Original Offline** option is not selected, a copy of the high resolution master version of the photo is downloaded to your computer. To select multiple photographs to be downloaded, hold down either the **Shift** or **Ctrl** key while clicking with the mouse. Then click the **Get Photos** button to transfer copies of the photographs from the CD to your computer. The photos can now be viewed in various ways and printed in different formats in the Adobe Photoshop Album program.

7

Using Adobe Photoshop Album

Introduction

The last two chapters showed how photographs can be viewed and managed using the photographic facilities built into Microsoft Windows XP, the operating system used to run most new computers. This chapter looks at Adobe Photoshop Album, a program designed specifically to view and manage photographs on a computer.

Adobe Systems Incorporated also produce Adobe Photoshop, the "industry standard" software used by publishing professionals for editing and enhancing photographs. (The home user version, Adobe Photoshop Elements, is discussed later in this book).

Photoshop Album is an inexpensive package (under £40 at the time of writing) and is compatible with later versions of Microsoft Windows such as Windows 98 Second Edition, Windows Millenium, Windows 2000 and Windows XP.

The software provides a comprehensive range of features for viewing and managing photographs, including:

- Importing photographs from digital cameras, scanners, files and folders, hard discs and CDs.

- Displaying photographs in various sizes as a grid of thumbnails, singly and as a slideshow.

- Enabling photographs to be displayed with suitable *captions* which can include both text and short *audio* recordings.

- Displaying photographs to include the date created. A *timeline* and a *calendar* enable photographs to be located according to their dates.

- Adding *tags* or labels to photographs enabling them to be displayed in various categories. This makes it easier to find and display photographs.

- "Fixing" photographs with single-click buttons to alter properties such as the colour or contrast, etc. (*Digital editing* is discussed in more detail in the next three chapters).

- Using photographs for *creations* such as photo albums, greeting cards, calendars, etc.

Adobe Photoshop Album also has facilities for printing, e-mailing and posting photographs to Web sites. These topics are discussed later in this book.

Getting Started with Photoshop Album

Installing the software is simply a case of inserting the installation CD in the drive and following the instructions which appear automatically on the screen. Once installed you can launch Photoshop Album by double-clicking its icon on the Windows Desktop. Alternatively, click **start**, **All Programs** and **Adobe Photoshop Album**, as shown below.

The **Photoshop Album** window opens up with the main window or *photo well* initially blank. As will be seen in more detail later, the well is the area of the screen used to display photographs as thumbnails on a grid.

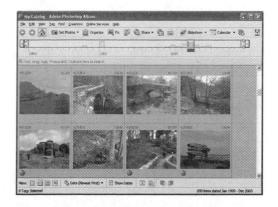

When you start the program, the **Photoshop Album Quick Guide** pops up on the centre of screen, as shown below.

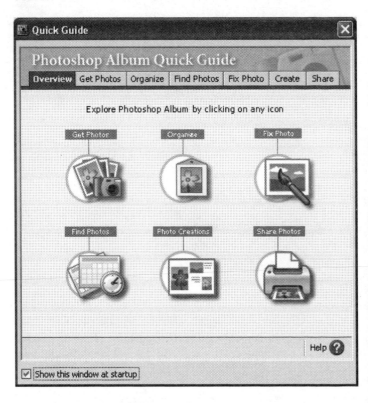

The **Quick Guide** has seven tabs as shown above, with the **Overview** tab currently selected. Clicking the **Get Photos** tab, for example, demonstrates methods of importing photos from various sources into Adobe Photoshop, as shown on the next page.

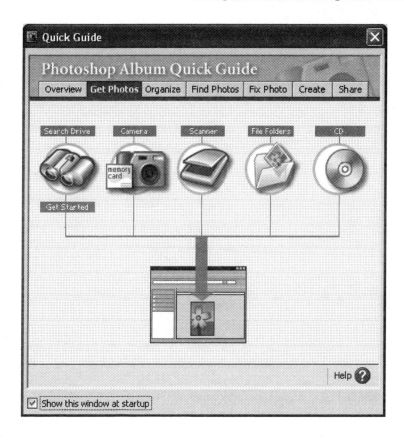

As can be seen above, you can import pictures from various sources, such as hard disc drives, a digital camera or memory card, a scanner, a CD or from specified files and folders. If you want to import files into Photoshop Album from one or more hard disc drives on your computer, click **Search Drive**, choose the hard disc(s) to be searched then click the **Search** button. A list of folders containing photographs is then displayed, as shown on the next page.

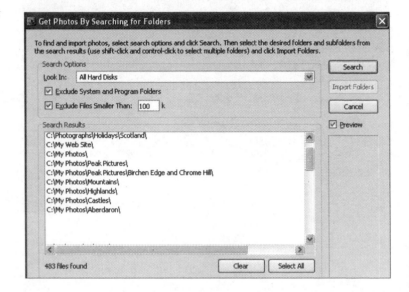

The two options shown above, **Exclude System and Program Folders** and **Exclude Files Smaller than 100K** are intended to save time when searching for photographs. **System and Program** folders need not be searched as they are most unlikely to contain photographs. Similarly files under **100K** are unlikely to be photographs, which are often more like **500K**.

From the list of folders containing photographs, you now select those folders and subfolders you wish to import into Photoshop Album. To select continuous blocks of folders, hold down the **Shift** key while clicking with the mouse. To select multiple folders which are not adjacent in the photo well, hold down the **Ctrl** key while clicking with the mouse.

After selecting the photographs, click the **Import Folders** button shown on the previous page. The photographs now become part of the Photoshop Album *catalog* and are displayed as thumbnails in the *photo well* as shown below.

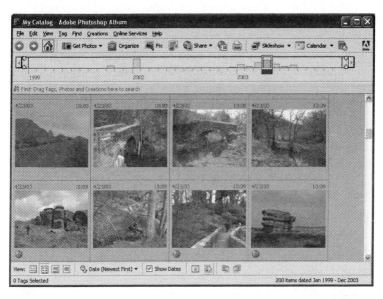

In fact the catalog in Photoshop Album doesn't actually contain copies of the photographs themselves. Instead the catalog tracks the *locations* on the hard disc where the photographs are stored, enabling them to be retrieved, displayed and managed. Also shown in the photo well above are the dates and times when the photograph files were created. As shown below there are buttons along the bottom of the Photoshop Album window to allow the photographs to be displayed in date order in various ways.

The four buttons shown on the left allow you to change the size of the photographs displayed in the well. The buttons are located at the bottom left of the photo well, shown below.

The first three buttons on the left above cause the photographs to be displayed as a grid of thumbnails of different sizes. The fourth button displays a selected photograph on its own, as shown below.

There is also an option to display the photographs as a **Slideshow**. This can be launched from the icon shown on the right and also shown on the shortcuts bar shown below.

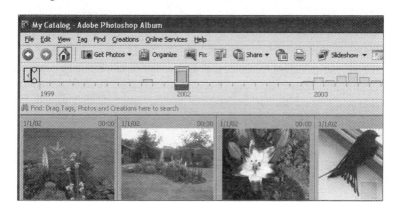

When you start the slideshow each photograph fills the entire screen. The photographs are changed automatically after a few seconds or you can use the control buttons, shown on the right, to change the pictures.

Organising Photographs Using Tags

The previous chapter, Managing Photos in Windows XP, showed how photographs could be organised into different categories using *folders*. Photoshop Album uses *tags* to create groups of photographs in different categories. Tags are similar to labels attached to luggage. Initially there are four tag categories provided, namely **People**, **Places**, **Events** and **Other**. You can also create new subcategories if you wish. The **Tags** pane can be opened by clicking the **Organize** icon on the shortcuts bar as shown right and below.

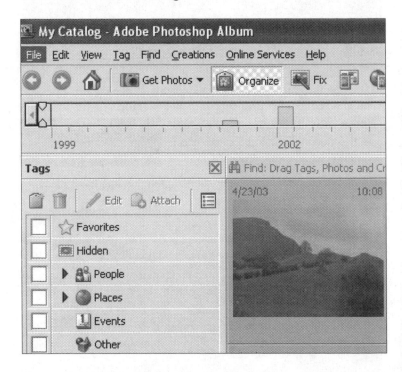

To create a new tag, click the icon in the top left-hand corner of the **Tags** pane, as shown on the right.

The **Tag Editor** dialogue box opens as shown below. You must choose a category by clicking the arrow to the right of **Category**, shown left. Here you can also create your own **Sub-Category**.

Having selected a **Category**, enter a meaningful **Tag Name** and if you wish add some relevant comments in the **Note** box, shown below.

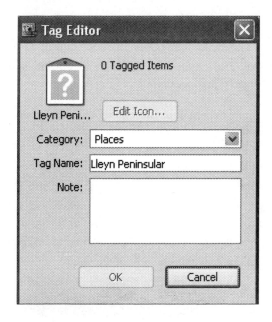

When you click **OK** the new tag, **Lleyn Peninsular**, joins the list in the **Tags** panel as shown on the left below.

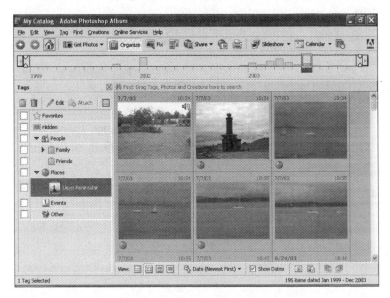

To apply the new tag (or tags) to selected photographs in the photo well, as shown on the right above, select the tag (or tags) and drag onto one of the selected photographs in the photo well.

Multiple tags or photos can be selected by clicking the mouse while holding down either the **Shift** key (for adjacent photos) or the **Ctrl** key (for non-adjacent photos).

Once the required photos are tagged, clicking the box next to the tag name in the **Tags** pane causes only the tagged photographs to appear in the photo well, as shown on the next page. When a tag is displayed, a binoculars icon appears in the box on the left of the tag.

As shown below, the **Lleyn Peninsular** tag was attached to four photographs. Clicking next to the name in the **Tags** pane, displays those photographs in the photo well.

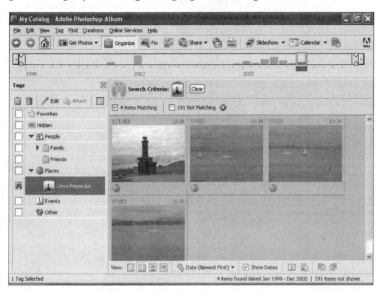

When you display a collection of tagged and untagged photographs in the photo well, the tagged photos display a small globe icon at the bottom left. If you allow the cursor to hover over the globe icon the name of the tag attached to the photograph will be revealed, as shown below.

Apart from clicking the box next to one or more tags, you can search for photographs by dragging tags onto the **Search Criteria** window as shown below.

On the right of **Search Criteria** shown above is the icon for the tag which is the subject of the current search. Please note in the above window, and also shown enlarged on the right, there are icons for creating, deleting and editing tags (reading from the left). Editing a tag allows you to change

the **Tag Name**, the **Category**, and to edit the icon.

After looking at a group of tagged photographs you may wish to return to display the entire catalog in the photo well. This is achieved by clicking an icon on the shortcut bar, shown on the right and below.

Finding Photographs by Date

Using the Timeline

Photoshop Album displays a **Timeline**, showing the dates when photographic files were created.

Each vertical bar or column on the timeline represents a particular month, revealed by allowing the cursor to hover over the bar. The higher the bar, the more photographic files were created in that month.

Photographic files created within a certain range of dates can be viewed by selecting **Find** and **Set Date Range** from the Photoshop Album menu bar, as shown below.

After entering the start and end dates, click **OK** to display the relevant photographs in the photo well.

Using the Calendar

When you click the calendar icon on the shortcuts bar, as shown on the right, you can scroll through different years and months and see the photographs taken at a given time. If more than one photograph was taken on a certain day the calendar displays the first photograph for that day. If you click on a day containing more than one photograph, a mini-slide show is launched, as shown below.

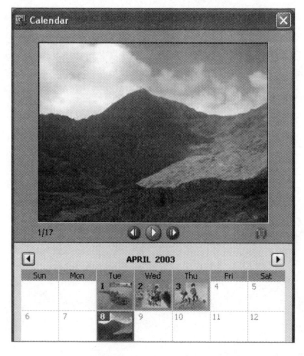

When you find the photographs you are interested in, click the **View** button, (shown as a pair of binoculars above and right) to see the chosen photographs in the various viewing options of the photo well.

Adding Captions to Photographs

Photoshop Album allows you to add two sorts of *caption* to your photographs - a piece of text and/or a short audio recording. To add captions to a photograph, select the required thumbnail in the photo well. Then click the **Properties** button shown on the right and also shown towards the bottom left of the screenshot below.

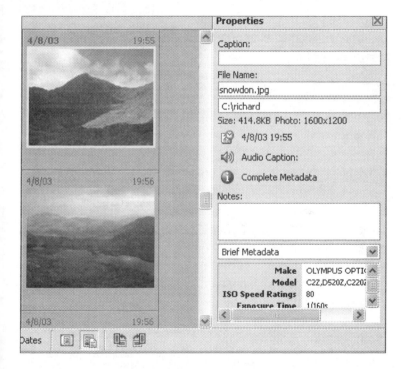

The **Properties** dialogue box opens as shown on the right above. To enter a piece of text as a caption simply type the text into the **Caption** bar.

Audio Captions

To add an audio caption, your computer must be fitted with a working sound card, speakers and a microphone.

Click the icon next to the words **Audio Caption** shown on the right and on the previous page.

A small recorder appears allowing you to record and save a short message to accompany the photograph.

When you close the window shown on the right, the audio caption is saved and attached to the photograph.

After recording both text and audio captions, any photo with an audio caption attached displays the audio icon on its image in the photo well, as shown on the right.

If you click the **Slideshow** button shown below, the text

captions are displayed on each photograph and the audio captions are played automatically.

Photoshop Album Creations

The **Creations** feature in Photoshop Album allows you to present your photographs in a variety of different forms and styles. You can start a creation from the **Quick Guide** which normally appears when you start Photoshop Album.

Click the **Create** tab as shown below.

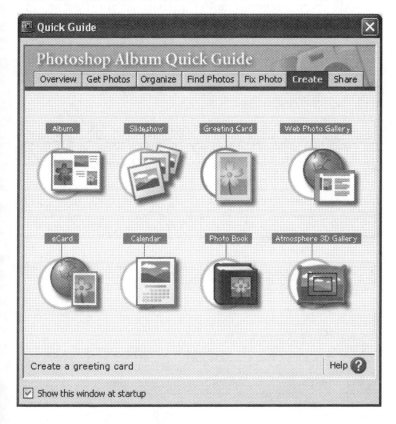

As can be seen above, your photographs can be incorporated into a wide choice of templates.

The **Album** shown on the **Quick Guide** on the previous page can be printed on a home computer. The **Slideshow** can be e-mailed to someone else. **Greetings Cards** can be printed on your computer while **eCards** and **Video CDs** are intended for viewing on a computer or television. **Calendar** is based on your own photographs and **Photo Book** is a bound album of your photos ordered on the Internet and posted back to you by the traditional mail.

To start a creation, select the required photographs in the photo well then start the **Quick Guide** from its icon on the toolbar, shown right. Click the **Create** tab.

Alternatively click **Creations** and **New** off the menu bar or click the creations button, shown on the right, on the shortcut bar. The **Workspace** window opens, displaying the selected photographs. When you click **Start Creations Wizard...** the wizard then guides you through your chosen creation, including any titles, greetings and messages, etc.

Digital Editing Basics

Introduction

One of the advantages of digital photography is that you can polish and improve an image after it has been saved on your hard disc. *Digital editing* allows you to modify and enhance photographs in ways which are just not possible using traditional images on film. For example, editing may be needed to compensate for poor conditions at the time the picture was taken or to correct faults such as scratches in old prints which have been scanned into a computer. You can even alter the composition of a picture by adding, deleting or moving people or objects.

Numerous digital editing software packages are available. For example, photographs in professional magazines, etc., are normally edited using the well-known Adobe Photoshop program. This software package costs several hundred pounds, but fortunately there is a home user version, Adobe Photoshop Elements, costing around £70. There are many other useful and inexpensive digital editing programs, such as Ulead Photo Express from Ulead Systems, Inc and PictureIt from Microsoft.

8 Digital Editing Basics

Shown below is a screen from the CAMEDIA Master software supplied with Olympus cameras. The **Image Edit** feature has a full range of editing tools as shown below.

The free or inexpensive programs just discussed will allow you to carry out basic improvements such as adjusting the brightness or contrast or rotating and cropping a picture. For more complex digital editing, programs such as Paint Shop Pro and Adobe Photoshop Elements are available. These are discussed in the next two chapters.

Some of the main uses of digital editing software are:

- To import photographs from digital cameras and scanners, as discussed earlier in this book.

- To enhance photographs by adjusting effects such as brightness, colour balance, focus and contrast.

- To allow images to be resized, cropped and rotated.

- To repair damage and faults such as scratches and "red-eye".

- To provide special tools for retouching photos, cloning and "stitching" into panoramas.

- To enable photographs to be incorporated into various creations or projects such as greeting cards, flyers and CD covers.

- To save photographs in various forms, suitable for printing, e-mailing and sharing on the Web.

More powerful programs, such as Paint Shop Pro and Photoshop Elements, allow images to contain a number of superimposed *layers*. These enable parts of an image to be edited and changed without affecting the rest of the image.

Digital Editing in Adobe Photoshop Album

Photoshop Album has a **Fix** feature which provides easy-to-use digital editing facilities such as adjustments to the colours, contrast and brightness of photographs. More advanced digital editing software, such as Photoshop Elements and Paint Shop Pro, is discussed later.

To start editing, open Photoshop Album and select the image to be edited, as shown below. Then click the **Fix** icon shown on the right and also on the shortcut bar in the window below.

A small window appears in the centre of the screen, shown above, stating that the original photo will not be changed. Instead the changes are written to a new file with the word **edited** appended to the file name, as shown below.

> You are about to edit an original photo; however, the original file will not be changed.
>
> Your changes will be written to the file:
> ... and Hollinsclough 026_edited.jpg

After clicking **OK**, the **Fix Photo** window opens up showing the photograph ready for editing.

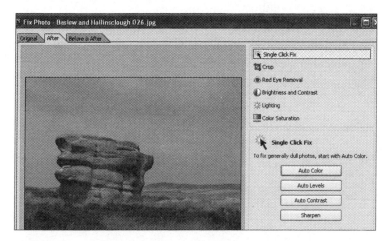

Single-Click Editing

Down the right-hand side shown above are the main editing tools, several of which can be applied using a single click. Dull pictures, for example can be improved using the buttons shown on the right.

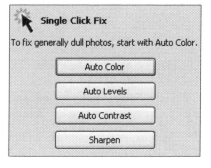

At the top left of the **Fix Photo** window are tabs enabling the photo to be displayed in the **Original** state, **After** fixing and both **Before and After**, shown on the next page. The **Help** notes in the program advise that for best results only one of the single-click **Auto...** buttons shown above is used. The **Sharpen** button is used to remove fuzziness and may be used in addition to any one of the **Auto...** buttons.

After using one of the **Single Click Fix** buttons, if you decide that you don't like the result, an **Undo** button allows the change to be aborted.

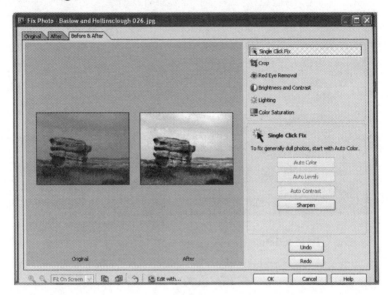

The group of editing tools at the top right of the **Fix Photo** window shown above and on the right, allow the user to exercise more control over any changes. For example, when you select any of the bottom three controls, **Brightness and Contrast**,

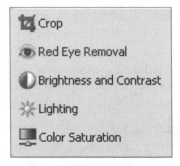

Lighting and **Color Saturation** sliders appear allowing you to make your own adjustments. As an example the **Brightness and Contrast** sliders are shown on the next page.

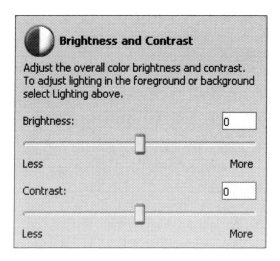

Cropping a Photograph

This is an important feature in all digital editing programs. Cropping allows you to select an area, usually near the centre of a photograph, then dispense with all surrounding material. Then the cropped image may be enlarged.

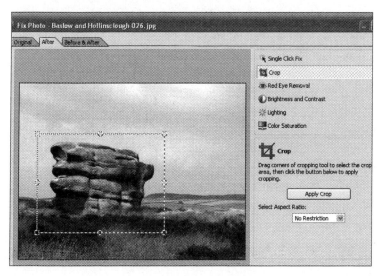

When you select the **Crop** command, as shown on the previous page, a rectangle of moving dashes is displayed on the screen. Anything outside of this rectangle will be removed in the crop operation. You can adjust the size of the rectangle using the small

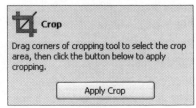

squares around its perimeter. The rectangle can be moved to a new position by placing the cursor inside of the rectangle and dragging with the left-hand button held down. When you are happy with the selected area for the crop, click the **Apply Crop** button shown above. The result of a cropping operation is shown below.

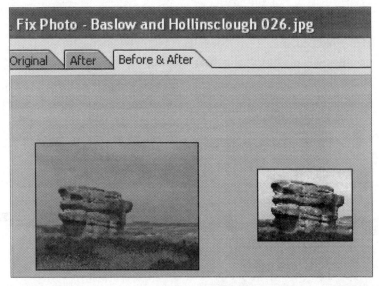

In the above **Before** and **After** images, apart from cropping, the **After** photo on the right has also been improved by using the single-click fix for **Auto Color**.

Removing "Red Eye"

The final digital editing tool in Photoshop Album is the removal of the "Red Eye" phenomenon, often seen in portrait photographs. Click the **Red Eye Removal** button shown below then adjust the resulting rectangle to surround both eyes. Then click the **Apply Red Eye Removal** button, as shown below, to improve the image.

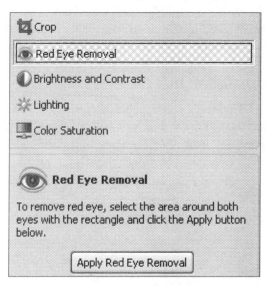

Along the bottom of the **Fix Photo** window shown previously is the small toolbar shown below.

Reading from left to right above, the first three tools allow you to zoom in and out of the image, or to select the magnification of the image as a percentage, as shown on the pop-up menu on the left.

The next two icons on the toolbar shown on the previous page *rotate* the image left or right in steps of 90 degrees.

The arrow icon shown on the right enables you to revert to the original image, if necessary.

This is followed by the **Edit with...** icon shown on the right, which allows you to switch the image to a more powerful digital editing program such as Photoshop Elements, discussed in Chapter 10.

You can set Adobe Photoshop Album to **Edit with...** a different program such as Paint Shop Pro. This can be set up by selecting **Edit**, **Preferences** and **Editing** and **Other Editors**, then browsing to select the digital editing program of your choice, which must be already installed on your computer.

Further Digital Editing

Easy-to-use software such as the **Fix** feature in Adobe Photoshop Album just described allows you to enhance photographs quickly and easily. The results can be quite pleasing and perfectly adequate for many purposes. However, if you want to delve deeper into the subject of digital editing then more powerful packages such as Jasc Paint Shop Pro and Adobe Photoshop Elements are needed. These are discussed in the next two chapters.

Editing Photos in Paint Shop Pro

Introduction

This chapter looks at Paint Shop Pro, one of the most popular *digital editing* programs. Although easy to use and reasonably priced, the program has a lot of powerful features enabling photographs to be improved and modified in many different ways. The next chapter looks at Adobe Photoshop Elements, another very popular digital editing program. Both programs have extensive help facilities with demonstrations, tutorials, hints and tips, also including "online" help from the Internet.

If you wish to take digital editing a step further than the basic features discussed in the last chapter, then either of these two programs, Paint Shop Pro or Photo Shop Elements, will perform admirably. Both programs have a huge range of powerful editing tools, too numerous to describe in this particular book. This doesn't mean the programs are too complex for the ordinary person to use, even though some of the advanced features may challenge the enthusiastic amateur and probably some professionals.

The next two chapters therefore can only give an overview of Paint Shop Pro and Adobe Photoshop Elements and describe some of the main editing tasks which can be performed on digital photographs.

Functions of Digital Editing Software

Some of the main functions of digital editing programs like
Paint Shop Pro and Photoshop Elements are:

- Acquiring photographic images from different
 sources - digital camera, card reader and scanner.

- Enhancing photos to improve brightness, contrast,
 removing "fuzziness", etc., using both precise
 manual controls and automatic "quick fixes".

- Re-touching with various brushes and tools,
 applying artistic effects and removing scratches.

- Rotating images in steps of 90 degrees. Also
 rotating by very small angles to *straighten* an
 image and remove *skew*.

- *Cropping* an image to remove unwanted material,
 usually around the outside of the image.

- *Enlarging* an image, including *resampling* to
 maintain image quality by adding pixels.

- *Cloning*, in which an object (or person) is removed
 from an image without trace by obliterating with a
 copy of part of the surrounding background.

- Changing the colour of an entire object or group of
 objects, without affecting the rest of the image.

- Creating an image as a group of superimposed
 layers which can be edited independently.

- Saving images in different file formats such as
 JPEG and TIFF, suitable for sending as e-mail
 attachments, posting to Web sites and printing.

- Printing multiple pictures in various page layouts.

Installing Paint Shop Pro

You can buy a boxed edition of Paint Shop Pro from the usual mail order or High Street sources. Alternatively you can purchase online from the Internet or download a *trial version*. To evaluate Paint Shop Pro, log onto the Web site at **www.jasc.com**.

Paint Shop Pro 8

Welcome to the Jasc Download Center

Jasc Software offers Trial versions of every product, so you can evaluate the software before you purchase. Every Trial version is completely free, fully functional, and runs for 30 days. We also offer full support for your Trial versions including free technical support. **Test-drive one today!**

Click the **free downloads** button and you will be asked to select a folder into which the downloaded file, **psp801ev.exe**, is to be saved. If you have an ordinary modem (as opposed to *broadband*), the download may take over 4 hours, as this is a very big file (55MB). If you don't have a broadband Internet connection yourself, perhaps you could ask a friend with broadband to download the file onto a CD for you - then it should only take about 11 minutes. Once you have saved the downloaded file either on your computer or on a CD, double-click the file name **psp801ev.exe** to install the Paint Shop Pro program ready for use.

If you have bought a boxed copy of Paint Shop Pro simply insert the CD and follow the instructions on the screen.

Opening Images from a Hard Disc

Paint Shop Pro can be launched by double-clicking its icon on the Windows Desktop. This icon is placed on the desktop automatically during the installation process. Alternatively the program can be launched by selecting *start*, **All Programs**, **Jasc Software** and **Jasc Paint Shop Pro 8**.

Photographs already stored on your hard disc can be loaded into Paint Shop Pro by clicking **File** and **Open...** then finding the required folder in the **Look in** bar.

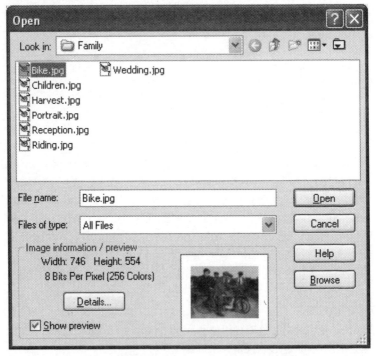

When you click **Open** the photograph is displayed in the main Paint Shop Pro window shown on page 126.

Acquiring Images from Another Device

As discussed earlier in this book, photos can be downloaded to a computer from devices such as a digital camera, a memory card reader and a scanner. Paint Shop Pro can download images directly from these devices using the **File** and **Import** command.

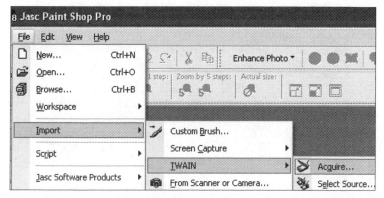

In order to import images from a camera, card reader or scanner, you must have previously installed the special *driver* software supplied with the device. Many scanners and digital cameras conform to a standard known as *TWAIN*, in which case the **TWAIN** option shown above should be selected.

Some cameras and memory card readers, when connected by a cable to a computer, appear as just another disc drive. Images can be imported from them using **File** and **Open...** just as if the images are already stored in a folder on your hard disc. Such connected devices are known as *mounted drives*. For example, my Belkin memory card reader appears in My Computer as **SmartMedia (E:)** and the Olympus digital camera appears as **Removable Disk (G:)**.

 SmartMedia (E:) Removable Disk (G:)

The Paint Shop Pro Window

Once you have selected the image to be edited, from whatever source, the image is opened in Paint Shop Pro ready for editing, as shown below.

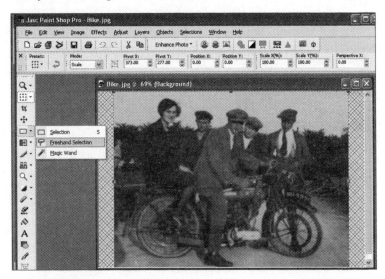

Down the left-hand side above is the **Tools** palette. This includes tools for all of the major editing tasks such as

zooming in and out, straightening an image, colour replacement, cropping, cloning and scratch removal. A full range of painting tools is included and there is a text tool allowing you to add a caption to a photograph. To reveal the function of a particular tool, allow the cursor to hover over the tool icon. An explanatory

label appears shortly, as shown on the left above for the **Crop Tool**.

Some of the tool icons shown in the **Tools** palette have a small down-arrow on their right. Clicking this arrow reveals further tool options, such as the three different types of selection tool shown on the right.

When a tool is selected from the **Tools** palette on the left of the Paint Shop Pro screen, the **Tools Options** palette along the top of the screen changes to display settings or **Presets** relevant to the tool selected. For example, if the **Zoom** tool is selected, a list of zoom settings appears, which can be adjusted by the user, as shown below.

At the top of the above extract from the Paint Shop Pro screen is the familiar **Menu Bar** used in most programs. Drop-down menus appear when any of the words such as **File, Edit, View**, etc., are selected. Beneath the menu bar is the **Standard Toolbar** with options such as opening an image, scanning, saving and printing. To the right is the **Photo Toolbar**, starting with the drop-down menu **Enhance Photo**. These toolbars can be switched on or off after selecting **View** and **Toolbars**.

Enhancing a Photograph

A photograph can be improved to compensate for poor lighting and weather conditions, etc. If you are not sure about individual operations to adjust photographic properties such as colour balance, contrast or saturation, simply click **One Step Photo Fix...** from the **Enhance Photo** menu shown below. Paint Shop Pro will then make changes to the photograph automatically.

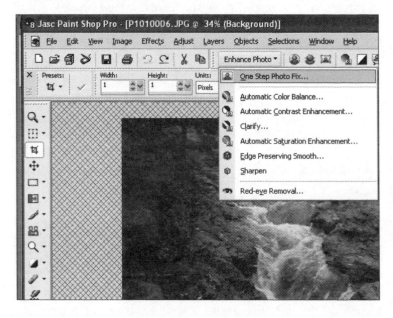

This should bring about a significant improvement in the clarity of the photograph. However, if you are not happy with the result of the operation, click **Edit** and **Undo One step photo fix** to revert to the original image.

The enhancement features can be selected individually from the **Enhance Photo** drop-down menu shown on the right. For example, if you select **Automatic Color Balance...**, the following dialogue box appears showing parts of the image before and after any changes.

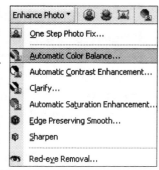

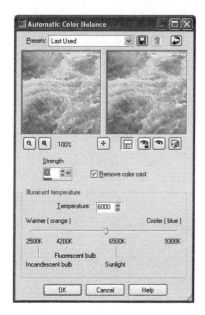

To accept the changes to the colour balance offered by Paint Shop Pro, click **OK**. Otherwise you can experiment with the various settings as shown above. **Automatic Contrast Enhancement...**, **Clarify....**, etc., can also be adjusted individually as shown in the **Enhance Photo** menu above.

Rotating an Image

Images can be rotated clockwise and anti-clockwise in steps of 90 degrees. For example, there may be occasions when it is convenient to take a photo with the camera held vertically. The resulting image can be rotated by selecting **Image** and **Rotate** from the Paint Shop Pro menu bar as shown below.

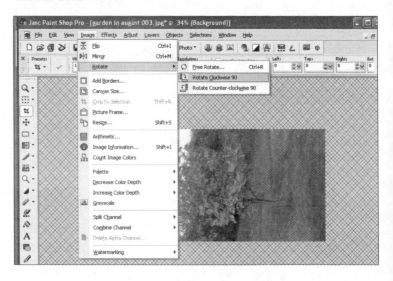

The 3 rotation options are shown on the right. **Free Rotate...** allows you to specify your own angle of rotation in degrees.

The previous image of the tree on its side is shown below after a 90 degree clockwise rotation.

Straightening an Image

If the camera is not held exactly horizontally (or vertically) the resulting image will have a slight skew. Similarly if a photographic print is not exactly straight when placed in a scanner, the resulting scanned image will be skewed. Paint Shop Pro uses the **Straighten** tool to remove any skew.

A guide line containing two "grab handles" appears on the screen. The guide line is adjusted to line up with a feature you want to be horizontal in the corrected image. Then you click the tick in the **Tools Options** palette, shown on the right, to remove the skew.

As shown on the **Tools Options** palette below there is also an option to **Crop** the image after the straightening operation. This ensures the edges of the image are vertical and horizontal after the straightening.

Perspective Correction

Objects such as buildings can sometimes appear to be slanting in photos. The **Perspective Correction** tool adjusts the image so that the

vertical and horizontal sides of an object appear correctly.

Cropping an Image

This involves selecting an area, usually in the centre of an image, then trimming off the unwanted surrounding parts of the image. The **Crop** tool is selected from the **Tools** palette down the left-hand side of the Paint Shop Pro screen. A cross appears and this can be dragged to form the rectangular cropping area, which will remain after the cropping operation. Small squares around the perimeter, as shown below, allow the cropping area to be resized and it can also be moved by dragging.

You can also define the crop area using the **Tools Options** palette, which appears when the crop tool is selected.

Once you have set the crop area, double-click inside of the rectangle to trim off the surplus parts of the image.

The image is shown above after the unwanted parts of the garden have been removed by cropping. This image has also been *enlarged* using **Image** and **Resize...** off the Paint Shop Pro menu bar. A scale factor of 120% was used in this example.

The Cloning Tool

This tool is used when you want to remove an object (or person) from a photograph. The cloning tool is used to select a suitable area or source from the background and then paint this over the photograph, to obliterate the unwanted object. In the example below, the wheelie bin needs to be removed.

First the **Clone Brush** is selected from the **Tools** palette on the left-hand side of the screen.

The **Tools Options** palette across the top of the window now displays various settings for altering the size and shape of the **Clone Brush** as shown on the next page.

Next, with the **Clone Brush** selected, right-click over the part of the background you wish to use as the *source*, to cover up the unwanted object (the wheelie bin in this case). Then start painting over the unwanted object. You may need to experiment with the various sizes and shapes of brushes as shown in the **Tools Options** palette across the top of the Paint Shop Pro window.

After cloning out the wheelie bin, the garden picture looked like this.

Working with Layers

Layers are a very powerful feature in programs like Paint Shop Pro and Adobe Photoshop Elements, while they are not used at all in the more basic programs. A photograph normally consists of a single layer and this can be edited, saved and printed. However, the use of layers enables new images to be added and edited separately, giving greater flexibility. For example, you can improve the colour balance and contrast or move or resize a layer, without interfering with the rest of the photograph.

In this example, a new layer will be created as follows:

- An image of a mallard will be copied from a photograph in Paint Shop Pro, using **Edit** and **Copy**.

- A separate photograph of a garden will be opened up in Paint Shop Pro.

- The mallard will be "pasted" *as a new layer* onto the image of the garden, making a collage consisting of two layers. (Images can consist of many layers in practice).

- The mallard can then be edited as a separate layer, without interfering with the original garden, which is the background layer.

(In a multi-layer image, after all of the layers have been edited, it's possible to *merge* them into a "flat" image consisting of a single layer).

Creating a New Layer

First the photograph containing the mallard is opened up in Paint Shop Pro as shown below. Then it is selected by drawing round it using the
Freehand Selection tool from the **Tools** palette.

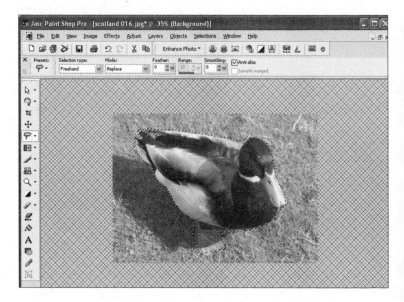

Then the image of the mallard is copied to the *clipboard* (a temporary storage area) by selecting **Edit** and **Copy** from the Paint Shop Pro menu bar.

Next the photograph of the garden is opened up in Paint Shop Pro, as shown on the next page.

Pasting a New Layer onto a Background Layer

Select **Edit**, **Paste** and **Paste As New Layer**. The mallard is pasted onto the garden. Initially it may be too big but this can easily be resized separately as described shortly. Now select **View**, **Palettes** and **Layers** to display details of the layers, as shown in the window **Layer - Raster 1** below.

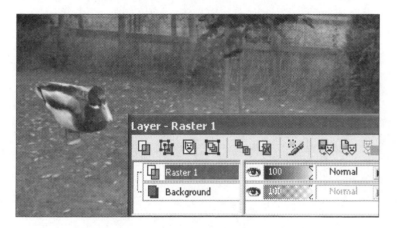

In the **Layer Palette** shown above, **Raster 1** is the layer representing the mallard. (*Raster* is a technical term relating to a particular method of displaying an image on a screen). **Background** is the layer representing the original photograph of the garden.

To start editing the mallard layer, it must be selected by clicking its entry, **Raster 1**, in the **Layer Palette**.

Refering to the **Layer Palette** shown above, clicking the eye icon can be used to "toggle" that particular layer on and off. For example, repeatedly clicking the eye in layer **Raster 1** shown above has the effect of making the mallard disappear and reappear.

Once a layer is selected, you can apply editing operations to that layer alone. To *resize* the mallard, select **Image**, **Resize...** and make sure **Resize all layers** is not ticked.

The layer can be resized by specifying dimensions in pixels or by a percentage scale factor.

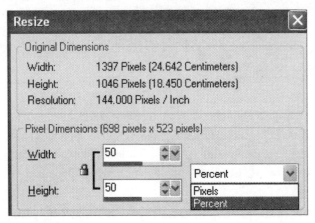

Moving a Layer

A layer such as the image of the mallard can be moved around the screen. Make sure it is selected in the **Layer** palette then use the **Move Tool** from the **Tools** palette shown on the right to drag the layer to its new position.

Saving a Photograph in Paint Shop Pro

When you've finished editing a photograph it should be saved as a file on your hard disc. If the file has been previously saved and you don't want to change the file name, etc., simply click the disc icon on the **Standard Toolbar** across the top of the screen.

Alternatively select **File** and **Save** from the Paint Shop Pro menu bar.

To save the photograph with a different file name, etc., click **File** and **Save As...** from the menu bar to open the **Save As** dialogue box shown below.

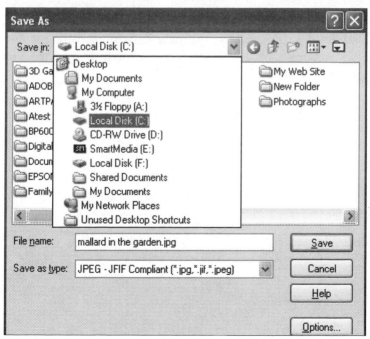

Entering the Save Location

As shown on the previous page, the **Save in** drop-down menu allows you to select the location where the photo is to be saved. This might be a different folder on the same hard disc, or on a second hard disc, a floppy disc or a CD.

Entering the File Name

You can make a new entry in the **File name** bar. The new file name should be meaningful so that you can identify the photograph easily in the future. Long file names like **mallard in garden** are quite acceptable in Microsoft Windows.

Entering the File Type

When you click the down arrow in the **Save as type** bar, shown below, a huge range of file types appears. Apart from specifying the file type for a new image file, you can also resave an existing photograph with a different file type. A sample of the file types available in Paint Shop Pro is shown below.

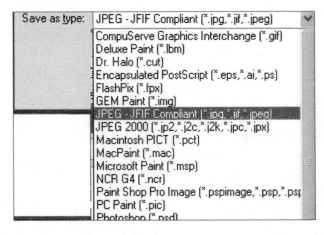

The JPEG File Type

The file type used to save a file is very important, especially in the case of photographs. The most popular file type for photographs is the **JPEG**, which uses **.jpg** as the extension to the file name as in **mallard in the garden.jpg**.

Photographs can have a very large file size, often over 500 kilobytes, depending on the resolution. If you are sending photographs to a friend by e-mail, these will take a long time to download using an ordinary modem. JPEG files can be *compressed* to reduce their size and therefore the time taken to send and receive them across the Internet. This type of compression works by discarding some of the image data, without any apparent deterioration in quality. This is known as "lossy" compression.

You can specify the compression when saving a file in the JPEG format by selecting **Options...** from the **Save As** dialogue box on page 141 and shown below.

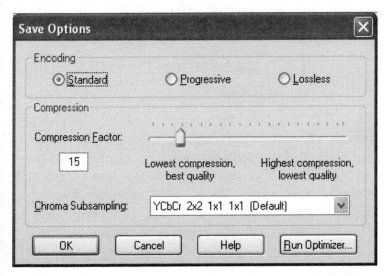

As can be seen in the **Save Options** window on the previous page, when you adjust the **Compression Factor** slider, there is a trade-off between compression and image quality. If the **Progressive** button is selected, when the image is loaded into a Web browser, a low-resolution image is displayed while the full version is loading.

Tagged Image File Format (TIFF)

This format uses a type of compression, known as **LZW**, which preserves most of the detail in an image. When you specify **TIFF** as the file type in the **Save As** dialogue box 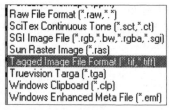 shown on page 141, selecting **Options...** allows you to make sure **LZW** compression is switched on.

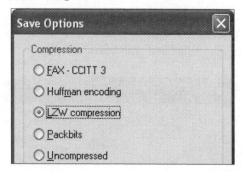

The TIFF format is therefore used for high quality printing of photographs in glossy magazines and publicity material, etc. TIFF photographs are too big for fast Internet use - a TIFF image can easily exceed 3 megabytes, for example. This can be more than 8 times the size of the same image saved as a JPEG, depending on the compression/quality settings discussed earlier.

Editing Photos in Photoshop Elements

Introduction

This chapter looks at Photoshop Elements 2, one of the most popular *digital editing* programs available. Photoshop Elements is a very close relative of Adobe Photoshop, the standard digital editing program used by professionals world-wide and costing several hundred pounds. Photoshop Elements is intended for the home and small businesss user and is therefore more modestly priced at around £70. Photoshop Elements is itself an extremely powerful program, with many sophisticated features.

However, the abundance of editing features in Photoshop Elements doesn't mean the program is difficult to use. There are lots of help features and tutorials built into the program with **Recipes** giving step-by-step instructions on how to perform different tasks. **Hints** are notes describing the various editing tools. To improve a photograph quickly and easily there are **Quick Fix** options which automate the task. Alternatively you can experiment with the vast range of digital editing tools in Photoshop Elements.

Please see page 122 for a list of some of the main editing features available in programs like Photoshop Elements and Paint Shop Pro (described in the last chapter).

Installing Photoshop Elements

You can buy a boxed edition of Photoshop Elements from the usual mail order or High Street sources. To evaluate a free trial version of Photoshop Elements, log onto the Web site at **www.adobe.com**.

Before clicking the button to download the program, you are informed that the trial version of Photoshop Elements occupies 111.1MB and takes over 5 hours to download using a standard 56K modem. If necessary, perhaps a friend with broadband could download the program onto a CD for you - then the job should only take a few minutes.

The download process places a file, **pse2.exe**, in a folder of your choice on your computer's hard disc. Double-clicking the file name **pse2.exe** in the Windows Explorer will install a full (trial) version of Photoshop Elements on your hard disc. This trial version of Photoshop Elements will cease to work after 30 days. If you've bought a boxed copy of Photoshop Elements simply insert the CD in the drive and follow the instructions on the screen.

Opening Images from a Hard Disc

Photoshop Elements can be launched by double-clicking its icon on the Windows Desktop. This icon is placed on the desktop automatically during the installation process. Alternatively the program can be launched by selecting *start*, **All Programs**, and **Adobe Photoshop Elements**.

Photographs already stored on your hard disc can be opened in Photoshop Elements by clicking **File** and **Open...** then finding the required folder in the **Look in** bar.

When you click **Open**, the photograph is displayed in the main Photoshop Elements window shown on page 150.

Acquiring Images from Another Device

As discussed earlier in this book, photographs can be downloaded to a computer from devices such as a digital camera, a memory card reader and a scanner. Photoshop Elements can download images directly from these devices, after clicking **Connect to Camera or Scanner** on the **Welcome** screen which by default appears every time Photoshop Elements starts up.

You can an also acquire images from the external devices such as the digital camera, etc., after selecting **File** and **Import** from the Photoshop Elements menus.

There is also an **Import** icon on the **Shortcuts** bar across the top of the Photoshop Elements window, as shown right and below.

In order to import images from a camera, card reader or scanner, you must have previously installed the special *driver* software supplied with the device. Many scanners and digital cameras conform to a standard known as *TWAIN*, in which case the **TWAIN** option shown on the previous page should be selected.

Some cameras and memory card readers, when connected by a cable to a computer, appear in My Computer as just another disc drive. Images can be imported from them using **File** and **Open...** just as if the images are already stored on your hard disc. Such connected devices are known as *mounted drives*. For example, my Belkin memory card reader appears in My Computer as **SmartMedia (E:)** and the Olympus digital camera appears as **Removable Disk (G:)**.

 SmartMedia (E:) Removable Disk (G:)

The Photoshop Elements Window

Once you have selected the image to be edited, from whatever source, the image can be opened in Photoshop Elements ready for editing, as shown below.

Down the left-hand side above is the **Toolbox**. This includes tools for all of the major editing tasks such as selecting an image, moving, cropping, colour replacement, cloning and scratch removal. A full range of painting tools

is included and there is a text tool allowing you to add a *caption* to a photograph. To reveal the function of a particular tool, allow the cursor to hover over the tool icon. An explanatory label appears, as shown on the left for the **Magic Wand Tool**.

Some of the tool icons shown in the **Toolbox** down the left-hand side of the screenshot below have a small down-arrow on their right. Clicking this arrow reveals further tool options in the **Options** bar across the top of the screen, such as the different types of selection tool shown on the right and below.

Please also note that as you allow the cursor to hover over an icon in the **Toolbox** shown on the left above, the **Hints** tab shown on the right above displays explanatory notes about each tool. In this example, **Rectangular Marquee** is the name given to one of the tools used for selecting areas of an image prior to editing.

Similarly there are various **Lasso** selection tools which allow you to trace round irregular shapes.

 The **Magic Wand** is a powerful tool which selects areas of a photograph according to their colour. You can set the **Tolerance** between **0** and **255** so that more or less of the area is included in the selection. With a high tolerance figure, a wider range of colours is selected. The selected colour can then be changed using **Enhance** and **Adjust Color**.

The **Selection Brush** allows you to select an area of an

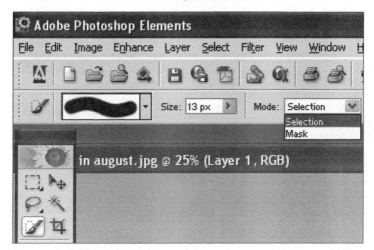

image by dragging. You can select various brush sizes, etc., from the **Options** bar shown below. The brush can be used to define either the **Selection** area or the **Mask** (*unselected* area), from the **Mode** menu shown on the right below.

The Menu Bar

At the top of the above extract from the Photoshop Elements screen is the familiar **Menu Bar** used in most programs. Drop-down menus appear when any of the words such as **File, Edit, Image**, etc., are selected.

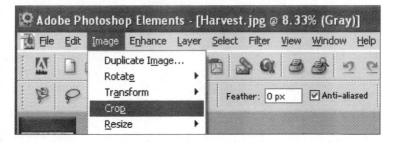

Enhancing a Photograph

A photograph can be improved to compensate for poor lighting and weather conditions, etc. If you're not sure about manually adjusting colour balance, contrast or saturation, etc., simply click **Quick Fix...** from the **Enhance** menu shown below. Or click the **Quick Fix** icon on the **Shortcuts** bar across the top of the screen.

The **Quick Fix** window shows images **Before** and **After** adjustments to properties such as brightness, contrast, focus and rotation.

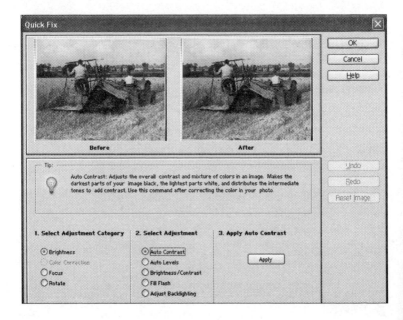

After clicking the **Apply** button, all being well there should be a significant improvement in the quality of the photograph. If you want to have more control over adjustments to the properties of an image such as **Brightness/Contrast** then click the button under **2. Select Adjustment** shown below.

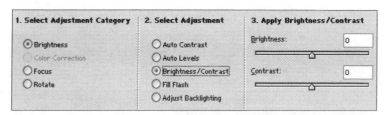

Use the sliding pointers shown above on the right to specify any changes and click **OK** to apply them. The **Quick Fix** window also has options to rotate an image through various angles. Ajustments to brightness, contrast, etc., can also be made from the drop-down menu after selecting **Enhance** from the menu bar.

The **Focus** button with **Auto Focus** selected is used to *sharpen* an image, as shown below.

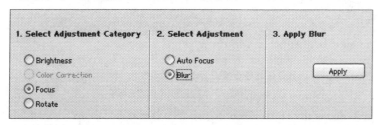

With **Blur** switched on, as shown above, an object can be made to stand out from its background. For example, to give a vehicle the impression of speed, the background is selected and then blurred.

Rotating an Image

Images can be rotated clockwise and anti-clockwise in steps of 90 degrees. This may be necessary, for example, when a photograph has been taken with the camera held vertically. The resulting image can be rotated by selecting **Image** and **Rotate** from the Photoshop Elements menu bar as shown below.

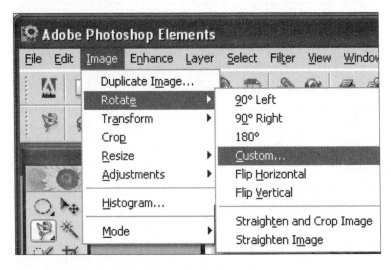

The **Custom...** option above allows you to enter your own angle of rotation of the image in degrees.

Straightening an Image

If the camera is not held exactly level the resulting image will have a slight *skew*. Similarly if a photographic print is not straight when placed in a scanner. Photoshop Elements uses the **Straighten Image** tool, selected from the **Image/Rotate** menu shown above, to remove any skew. **Straighten and Crop Image** trims the sides of an image to make them square after the straightening operation.

Cropping an Image

This involves selecting an area, usually in the centre of an image, then trimming off the unwanted surrounding parts of the image. The **Crop** tool is selected from the **Toolbox** down the left-hand side of the Photoshop Elements screen. The crop cursor appears on the screen and can be dragged to form a rectangle. The area inside the rectangle remains after cropping. Small squares around the rectangle allow the cropping area to be adjusted and the rectangle can be moved by dragging with the cursor.

Once you've set the crop area, double-click inside of the rectangle to trim off the surplus parts of the image. Alternatively click the tick shown right which appears towards the top right of

the main Photoshop Elements window, shown on the previous page. The circular icon above cancels the current crop operation. The cropped image is shown below.

This image has also been *enlarged* using **Image** and **Resize** off the Photoshop Elements menu bar. A scale factor of 120% was used in this example.

The Clone Stamp Tool

This tool is used when you want to remove an object (or person) from a photograph. The **Clone Stamp Tool** is used to select a suitable area or *source* from the background and then use this to paint over the photograph, to obliterate the unwanted object. In the example below, the wheelie bin needs to be removed.

First the **Clone Stamp Tool** is selected from the **Toolbox** on the left-hand side of the screen.

The **Tools** options bar across the top of the window now displays various settings for altering the size and shape of the **Clone Stamp Tool** as shown below.

Next, with the **Clone Stamp Tool** selected, while holding dow the **Alt** key, click over the part of the image you wish to use as the *source*. This will be used to paint over and effectively remove the unwanted object (the wheelie bin in this case). You may need to experiment with the various sizes and shapes of the tools as shown below in the **Tools** options bar across the top of the Photoshop Elements window. After cloning out the wheelie bin the garden picture looked like this.

Apart from removing objects and people from a photograph, the **Clone Stamp Tool** can also be used to remove scratches and other defects. This might be useful if you have scanned some old photographs which have become scratched and damaged over the years.

Working with Layers

Layers are a very powerful feature in programs like Photoshop Elements, while they are not used at all in the more basic programs. A photograph normally consists of a single layer and this can be edited, saved and printed. However, the use of layers enables new images to be added and edited separately, giving greater flexibility. For example, you can edit a layer by improving the colour balance and contrast or by moving or resizing, without interfering with the rest of the photograph.

In this example, a new layer will be created as follows:

- An image of a peacock will be selected and copied from a photograph in Photoshop Elements, using **Edit** and **Copy**. This places a copy of the image on the *clipboard*, a temporary storage area which facilitates copying between different windows.

- A separate photograph of a garden will be opened up in Photoshop Elements in its own window.

- The peacock will be "pasted" from the clipboard, *as a new layer*, onto the image of the garden, making a simple collage consisting of two layers. (Images can consist of many layers in practice).

- The peacock can then be edited as a separate layer, without interfering with the original garden, which is the *background* layer.

(In a multi-layer image, after all of the layers have been edited, it's possible to *merge* them into a "flat" image consisting of a single layer).

Selecting an Irregular Shape

First the photograph containing the peacock is opened up in Photoshop Elements, shown below. Then it is selected by drawing round it using the **Lasso Tool** from the **Toolbox**. This allows you to trace freehand around the outside of an irregular shape.

Then the image of the peacock is copied to the *clipboard* by selecting **Edit** and **Copy** from the Photoshop Elements menu bar.

Next the photograph of the garden is opened up in Photoshop Elements, as shown on the next page.

Creating a New Layer by Pasting

Select **Edit, Paste** and the peacock is pasted onto the garden as shown below. Initially it may be too big but it can easily be resized separately as described shortly. Now select **Window** and **Layers** to display details of the two layers, as shown in the **Layers** window below.

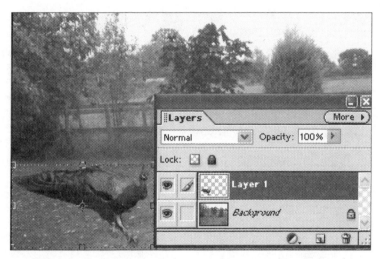

In the **Layers** window above, **Layer 1** is the peacock. The *Background* layer shown above is the original photograph of the garden.

To start editing the peacock layer, it must be selected by clicking its entry, **Layer 1**, in the **Layers** window.

Clicking an eye icon in the **Layers** window above can be used to "toggle" that particular layer on and off. For example, repeatedly clicking the eye in **Layer 1** shown above has the effect of making the peacock disappear and reappear. Once a layer is selected it can be enhanced, resized, moved or copied, etc., without affecting the rest of the image.

Saving a Photograph in Photoshop Elements

When you've finished editing a photograph it should be saved as a file on your hard disc. If the file has been previously saved and you don't want to change the file name, etc., simply click the disc icon on the **Shortcuts** bar cross the top of the screen.

Alternatively select **File** and **Save** from the Photoshop Elements menu bar.

To save the photograph with a different file name, etc., click **File** and **Save As...** from the menu bar to open the **Save As** dialogue box shown below.

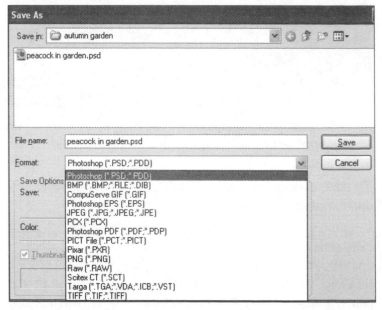

Please refer to the last chapter for more details of saving including different file types such as **JPEG** and **TIFF**.

11

Printing and Sharing Photos

Introduction

After you have edited your photographs to their highest quality and archived them safely to a CD, you'll probably want to show them to friends and relatives. Depending on your acquaintances' access to computer technology, this might be achieved in any of the following ways:

- Create prints on glossy paper like traditional photographs.

- Take a CD round to their home for a slide show on their computer. As discussed earlier, unedited pictures still in a digital camera can be viewed by connecting the camera to the video socket on an ordinary television set.

- E-mail copies of the photos to friends and relatives. These can be downloaded, saved and viewed on their computer.

- Display copies of the photos on a Web site which can be viewed by friends and relatives with access to the Internet, anywhere in the world.

Printing Digital Photographs

To make prints on glossy paper you need an *inkjet printer*. There is a now a wide choice of such printers capable of producing excellent colour photographs. These can cost anything from about £30 up to £200 or more. Well-known manufacturers of inkjet printers are firms such as Epson, Hewlett Packard, Canon and Lexmark. An Epson Stylus inkjet printer is shown below.

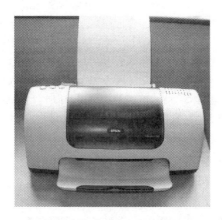

Some inkjet printers are styled *photo printers* because they are designed to give especially good quality photo prints. They may also produce prints without the use of a computer - you simply connect the digital camera to the printer using a USB cable. Some printers also have a slot to allow the camera's memory card to be inserted.

Connecting the camera or memory card directly to the printer in this way, without involving a computer, is fine if you just want prints quickly. One disadvantage is that there is no opportunity to view the photographs properly on a large screen and then reject any you don't want.

Printing directly without using the computer also means you can't enhance the pictures or carry out editing tasks like cropping, resizing, or cloning. A computer must also be used if you wish to e-mail the photographs or include them in documents, publications or Web sites.

While an inkjet printer can now be bought for under £30, the combined cost of the cartridges for some brands may be nearer £50. One solution is to buy much cheaper *compatible* or *remanufactured* cartridges from third party manufacturers, although there is some debate over their quality.

Printing your own photographs with an inkjet printer can be very slow - anything from about 5-20 minutes to print an A4 colour photograph. This is still quicker, however, than taking a traditional 35mm film to be developed.

Special glossy printer paper currently costs about £7 for 20 sheets and can produce excellent prints. As discussed later, multiple photos can be printed on one sheet of paper.

Alternatively you can take the memory card out of your camera and take it to High Street stores like Boots or Jessops who will produce glossy prints for you.

Or you can send photos to Jessops, etc., via the Internet. From your images they will produce high quality prints, greetings cards, coasters, etc., delivered to your door. Click **Order prints online** as shown on the right to start the process of connecting to an on-line printing service.

Printing Your Own Pictures

Open the folder containing your photographs in the Windows Explorer. You should see the **Picture Tasks** menu down the left-hand side of the screen, as shown right. Now select **Print pictures** and the **Photo Printing Wizard** opens up.

You can now select, with a tick, the photographs you want to print. There are also buttons to **Select All** and **Clear All**. After selecting the photos to be printed and clicking **Next**, the **Printing Options** window appears, enabling you to specify your **Printing Preferences**, such as **Photo** and **Best Photo** quality, as shown below for the Epson Stylus printer.

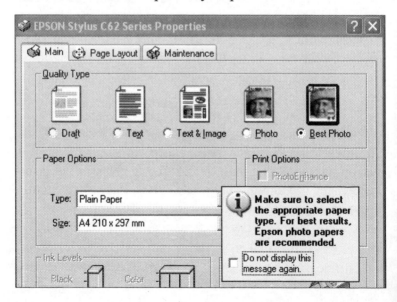

You are then given a choice of layouts and print sizes ranging from full size, i.e. one print per sheet, to 35 miniature **Contact Sheet Prints** per page.

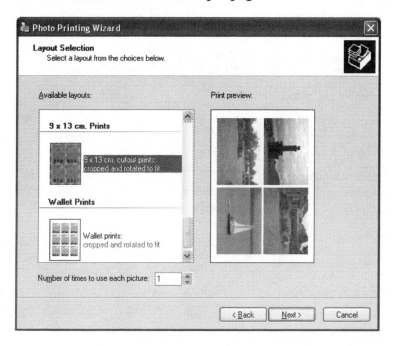

As shown above, you can also specify how many times you want each photograph to be printed. As mentioned earlier, printing a photograph can take several minutes on an inkjet printer. If the quality of the picture is disappointing then it may be that the nozzles in the print-head need cleaning. This can give rise to unsightly horizontal lines across the picture. The procedure for cleaning the nozzles in the Epson printer is described on the next page.

Cleaning the Print Head Nozzles

Click *start* and **Printers and Faxes**, then click your printer's name (it should be marked with a tick) and select **File** and **Printing Preferences**.... Now select the **Maintenance** tab, as shown below for the Epson printer.

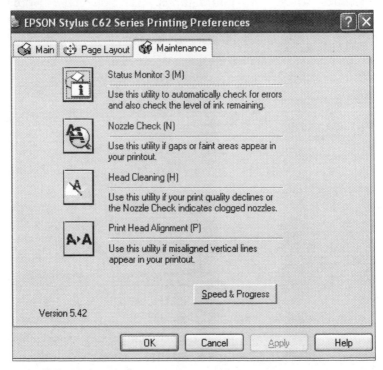

The **Status Monitor** above allows you to check the amount of ink remaining in the black and colour cartridges. The **Nozzle Check** prints a test piece to find out if the nozzles need cleaning, indicated by horizontal lines across the image. The **Head Cleaning** button shown above can be used to remedy this problem. Vertical lines can be corrected by the **Print Head Alignment** button shown above.

E-mailing Photographs

When you send an e-mail message, you can include with it additional files known as *attachments*. These can be any sort of file, usually selected from your hard disc. They could, for example, be word processing documents, graphics files, or photographs. If you take some memorable photographs which you would like to share with your friends and family around the world, e-mailing them will be both fast and inexpensive. Of course, your contacts must have access to an Internet-ready computer to receive and view the photographs.

Computers equipped with one of the latest *broadband* Internet connections can easily handle large files such as photographs. However, computers fitted with a traditional 56K modem will be much slower at both sending and receiving photographs. As discussed shortly, there are ways to reduce the size of photographs to speed up their transfer across the Internet as e-mail attachments.

Sending a Photograph as an E-mail Attachment

First the folder containing the photograph(s) is opened in the Windows Explorer.

11 Printing and Sharing Photos

The photograph I am going to e-mail is called **David and Richard.jpg**. As discussed earlier, the file has been saved in the popular **.jpg** photographic format. This is because the **.jpg** photograph can be compressed for sending over the Internet without appreciable loss in quality. As can be seen below, allowing the cursor to hover over the thumbnail photograph shows that this image has a size of **501KB**.

David and Richard.jpg

If we now *right-click* over the photograph in Windows Explorer, the following menus appear, allowing you to select **Send To** and **Mail Recipient** as shown below.

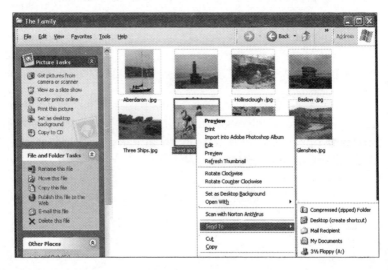

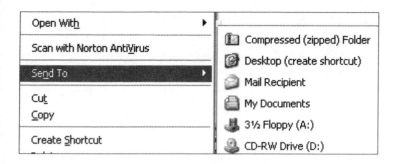

After clicking **Send To** and **Mail Recipient** as shown above, The following window appears, giving you the chance to reduce the size of your pictures.

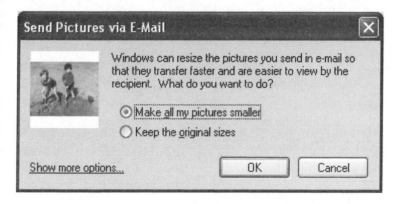

If you click **OK** to make the picture smaller, there is a short delay while the picture is reduced in size. Then your e-mail program opens up with the photo already inserted as an attachment, as shown on the next page.

Your e-mail program opens up automatically with a **Subject** for the e-mail already entered as shown below.

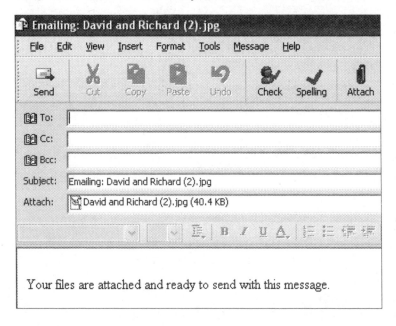

The file for the photograph has also been attached as shown above in the **Attach:** line, also shown enlarged below.

Please also note above that in preparing the photograph for e-mailing, Windows has reduced the size of the photograph from **501KB** to **40.4KB**. This should bring about a considerable saving in the time needed to send and receive the photograph across the Internet.

Now we need to enter the e-mail addresses of the friends or relatives who are to receive the photograph and also enter the text in the main body of the message. To test the system you can send the photograph to yourself by entering your own e-mail address in the **To:** bar. Then click the **Send** button.

The e-mail and attached photograph are now sent over the Internet. Next time the recipient reads their e-mail, an entry for the message appears, with a paper clip denoting the attachment, as shown below.

Double-clicking on the entry for the e-mail in the **Inbox** above opens up the e-mail, displaying the photograph's file name as an entry in the **Attach** bar, shown on the right.

Double-clicking the entry in the **Attach** bar shown on the previous page displays the **Open Attachment Warning** shown below.

Opening a file from the Internet can be a risky business. It is best to save the file to your hard disc then check it immediately with an up-to-date anti-virus program like Norton AntiVirus or Dr. Solomon's Anti-Virus Toolkit. (Also check for viruses any photographs or other documents before *sending* them as e-mail attachments.) When you click **OK** as shown above, the **Save As** dialogue box opens allowing you to select a folder and enter a file name for the newly received photographic file.

When the file has been saved to disc in a folder of your choice and checked for viruses, double-click the thumbnail or file name in the Windows Explorer as shown on the right. This displays the photograph in the **Windows Picture and Fax Viewer**, where it can be viewed as a film strip or slide show, rotated, printed or deleted.

David and Richard.jpg

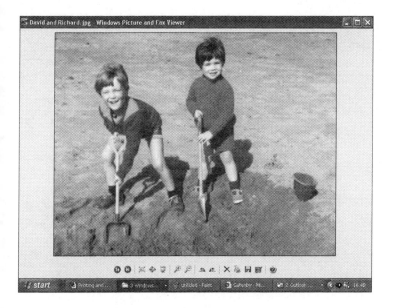

Although the photograph was greatly reduced to speed up the e-mail process, the quality of the image is still quite acceptable for general viewing on a computer screen.

Publishing Photographs on the Internet

You can post copies of your favourite photographs on the Internet for anyone in the world to view. With the folder containing your photographic files displayed in the Windows Explorer, make sure the **File and Folder Tasks** menu is displayed as shown below. If the **File and Folder Tasks** menu is not visible, select **View** and **Explorer Bar** and make sure the **Folders** option is *not ticked*.

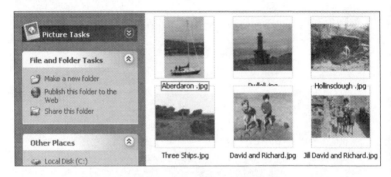

To copy photographs to a Web site we select the **Publish this folder to the Web** option shown above and on the right. This starts the **Web Publishing Wizard** and after the initial **Welcome** screen,

you can select the photos you want to publish by making sure they are ticked in the checkboxes on the thumbnails for each picture, as shown on the next page. Click to remove the tick from any photograph you don't want to publish on the Web.

On clicking **Next**, the **Web Publishing Wizard** obtains information about your Internet Service Provider. After selecting your Internet Service Provider's Web location for storing the photographic files, you can resize the pictures before they are published on the Web.

Then the process of copying the pictures to the Web begins and you are informed of progress, as shown below.

The **Web Publishing Wizard** finishes by telling you that you have successfully published your files. It will also display the Web address where other people, such as friends and family around the world, can view your photographs.

Index